TAKING THINGS SERIOUSLY

PUBLISHED BY
Princeton Architectural Press
37 East Seventh Street
New York, New York 10003

FOR A FREE CATALOG OF BOOKS,
call 1.800.722.6657.
Visit our web site at www.papress.com.

EDITING: Jennifer N. Thompson
DESIGN: Carol Hayes

SPECIAL THANKS TO:
Nettie Aljian, Sara Bader, Dorothy Ball,
Nicola Bednarek, Janet Behning, Becca
Casbon, Penny (Yuen Pik) Chu, Russell
Fernandez, Pete Fitzpatrick, Jan Haux,
Clare Jacobson, John King, Nancy Eklund
Later, Linda Lee, Katharine Myers, Lauren
Nelson Packard, Scott Tennent, Paul
Wagner, Joseph Weston, and Deb Wood
of Princeton Architectural Press —
Kevin C. Lippert, publisher

CAROL AND JOSH WOULD
LIKE TO THANK:
Mark Newgarden, Lynn Peril, Rosamond
W. Purcell, Richard Saja, and all of our
contributors.

LIBRARY OF CONGRESS
CATALOGING-IN-PUBLICATION DATA
Glenn, Joshua, 1967–
 Taking things seriously : 75 objects
with unexpected signficance / Josh
Glenn and Carol Hayes.
 p. cm.
 ISBN 978-1-56898-690-6 (papereback
: alk. paper)
 1. Values—Psychological aspects. 2.
Meaning (Psychology) 3. Relevance. I.
Hayes, Carol, 1971– II. Title.
 BF778.G44 2006
 153.4'5—dc22
 2006035812

TAKING THINGS SERIOUSLY.

75 Objects with Unexpected Significance

PRINCETON ARCHITECTURAL PRESS NEW YORK

table of contents

AND SOME CERTAIN
SIGNIFICANCE LURKS IN ALL
THINGS, ELSE ALL THINGS
ARE LITTLE WORTH, AND THE
ROUND WORLD ITSELF BUT
AN EMPTY CIPHER, EXCEPT
TO SELL BY THE CARTLOAD,
AS THEY DO HILLS ABOUT
BOSTON, TO FILL UP SOME
MORASS IN THE MILKY WAY.

—Ishmael, in Herman Melville's *Moby-Dick*

introduction

BY JOSHUA GLENN

Scraps of movie posters scavenged from the streets of New York by
Low Life author Luc Sante. A World War I prison camp hunk of bread
forced upon photographer Rosamond Purcell by an elderly neighbor.
The discarded bottle of Zippy-brand soda pop that gave cartoonist
Bill Griffith a logo for his comic strip. Step into the living room,
study, office, studio, or den of just about any engaged, imaginative,
passionate individual and you'll gravitate toward an item that,
although it may not appear particularly valuable, is reverentially
displayed as though it were a precious and irreplaceable artifact.
Inquire about the object's provenance and you'll be treated to a
lively anecdote about how it came into your host's possession. Keep
digging, and you might crack the code of what the thing *means*.
Just as we are collectors of things, things are collectors of meaning.

Charmed by such narratives and endlessly fascinated by the
human drive and capacity to invest inanimate objects with meaning,
a couple of years ago I suggested to Carol Hayes, a graphic
designer friend of mine, that we gather a book's worth of photos and
essays about ordinary things instilled with extraordinary significance.
An email sent to artists, designers, thinkers, and writers of our

mutual acquaintance sparked an enthusiastic response. Somewhere between the trash-picked, robot-shaped hairdo machine described by its owner as a chick magnet and the pair of yard-sale sunglasses imbued with the elusive secret of instant happiness, we decided that we were definitely onto something. After having secured the imprimatur of Princeton Architectural Press, we cast our net out again—this time contacting friends of friends, as well as chance acquaintances and perfect strangers—and hauled in what turned out to be an even more variegated, idiosyncratic, and thrilling collection of significant objects.

However, what had started innocently enough as a fun project became a provocative one—in good and bad ways—as soon as we started to receive more submissions than we could fit into the book. We then found ourselves in the intensely awkward position of being forced to reject people's most meaningful possessions. In some cases, this was because we'd already accepted similar objects. We could only include so many examples of mid-century and Cold War pop culture ephemera, for instance—though we absolutely had to have Mark Newgarden's Mickey Mouse Soaky, not to mention August Miller's kiddie jigsaw and Beth Daniels's TV-shaped pencil sharpener—before the book turned into a different sort of project. Often, however, we rejected submissions because we didn't find the person's significant object...well, significant enough. We were rejecting not only the object, in other words, but what you might call its meaning-value.

From out of my own fumbling efforts to justify our editorial decisions—I'm worried that I've permanently injured the feelings of several rejectees—we developed an ad-hoc and incomplete object-oriented meaning-value screen, which I'll attempt to describe below. At the same time, in the process of editing seventy-five essays whose

authors were asked to articulate and justify their intensely possessive feelings for a variety of unresponsive doodads and dinguses, I was provoked to revisit one of my favorite unanswerable philosophical questions: Is meaning inherent in the world, or do we invent it and impose it upon the world?

COMPLICATING THINGS

Regarding our editorial screening method, it turns out there are numerous types of significant objects whose meaning is so obviously determined, so agreed-upon-in-advance by the dominant culture, that it's become impossible to say anything insightful about them. Family heirlooms are an obvious example; so are childhood toys, cremains, and travel souvenirs. This is not to say that the cathexis through which we invest such things with mental and emotional energy is a shallow or inauthentic process. But we were more charmed and excited by the unlikely objects to which people had managed to give a unique, eccentric significance.

Elsewhere on the signification spectrum is another type of meaningful object that we also (mostly) eschewed: the aestheticized object, whether a work of fine, "bad," or outsider art, or a scavenged object repurposed as a Dada-esque readymade. We decided against including too many aestheticized objects because they are not only things, but—thanks to someone's self-conscious decision—they represent things too. They are not merely objects, that is, but a kind of text intended to be interpreted. We're most interested in objects that accidentally became interpretable.

Having said all of that, it has not escaped us that the meaning of souvenirs, heirlooms, childhood toys, and objets d'art can once in a while be described in new and compelling ways, particularly by those who purposely misappropriate and misinterpret them.

Punk and camp modes of signification are not alien to the editors' sensibilities. Objects that we might have rejected were it not for such outré considerations include: Amy Kubes's fingernails, the sculpted head that Clarke Cooper found on a beach, and Patrick Smith's Auschwitz souvenirs. As for *memento mori*, although we passed on pet cremains and skeletons, we were delighted to accept relics of a sanctified sort: the arm of David Scher's mother's couch, the bookplate swiped by Kim Cooper from the effects of a forgotten artist, the T-shirt that Jen Collins made while waiting for her mother to die.

Regarding the philosophical conundrum mentioned earlier —one that demonstrates the vertiginously complicated nature of the interaction between the human mind and the external world— there is no simple answer. Is meaning discovered or invented? Do everyday objects speak to us, even if not always in our own language, as Melville's Ishmael tries to assure himself? Or is the meaning of things concealed behind the "pasteboard masks" of the quotidian, as Melville's Ahab wrathfully insists? And even if we did manage to strike through these masks, might not Ahab's fear that "there's naught beyond" be realized?

Speaking of Ahab's barely repressed nihilism, we were surprised to discover that a small subset of the people we invited to participate in the book didn't attach any particular significance to objects. (Some of these folks were apologetic about this; others were a tad contemptuous.) We were also taken aback to find that only a few of the known collectors we contacted were able to extract from their collections a single meaningful object. The critic Walter Benjamin once claimed, in his essay "Unpacking My Library," that the act of collecting is one of conferring upon an object a value that derives not from the marketplace but from its

12

place within the collection. The downside of collecting, however, is that it doesn't confer unique value on any one object. Not that there's anything wrong with that—it just made our task more difficult. Thank goodness, then, for those collectors who did come up with significant objects: Lynn Peril and her thrift-store scrapbook, John F. Kelly and his Christopher Walken bagel, Paul Lukas and his light bulb, to name just a few. We've also included a couple of collections in their entirety, including what's left of Mimi Lipson's petrified cupcakes.

But back to the meaning of things. The discovery or invention of lively significance in objects is an ancient, even primitive human activity. So perhaps some people are reluctant to admit they find objects meaningful because they don't want to seem childish; after all, they don't talk to dolls any more. Dolls and other humanoid figures were one type of significant object we almost nixed, actually. But we received so many intriguing photos and stories about such things that we gave the category a reprieve. Same goes for animal figures: How could we pass on James Kochalka's stolen and re-stolen rubber pig, Melissa Holbrook Pierson's elegant ceramic whippets, or Joel Holland's bear lamp?

Holland describes his lamp-bear's posture and attitude as "totemlike," but let's call a totem a totem. Not a few of our contributors fiercely cherish objects of the animal, vegetable, or mineral persuasion: One thinks of William Drenttel's dried artichoke, Marilyn Snell's dirt pile, Tony Millionaire's snapping turtle tail. And according to the critic W. J. T. Mitchell, the flipside of totemism, which he partially defines as "the greeting of natural objects as...tutelary spirits," is fossilism, or "the ironic and catastrophic consciousness of modernity and revolution."[1] Plenty of the objects in this book can be read as petrified remnants of vanishing eras and

unforgotten childhoods: Mark Kingwell's useless film editor, the life ring that Katie Hennessey lifted from a commuter boat going out of business, Greg Klee's wobbly Santa, even Kris Moran's obscene novelty camera.

Then there are the talismans, a term that appears half a dozen times in these pages. Among those objects claimed to be charms, whether of the auspicious or malicious variety, are Paul Maliszewski's "CERTIFIED TRUE COPY" rubber stamp, Julian Hoeber's headlight knob, and Naomi Chichiwan's "ugly-pretty" inflatable doll. Another way to think of a talisman is as a thing-that's-good-to-think-about, which could describe almost any of the objects in the book. Consider Thomas Frank's World War I French artillery helmet, which he says serves to inoculate him against the allure of jingoism; Kristin Parker's Helltown vase, which helped inspire her to become a curator and archivist; or those objects contributed by the editors themselves: Carol's bewildering "THOUGHTS" sampler and my miscomprehended death mask.

Dolls, animal figures, totems, fossils, talismans: It all sounds very counter-Enlightenment. But is it? According to the philosophers, theorists, and critics I studied in college, which was at the height of postmodernism's reign in American humanities departments, sometimes we can leverage pre-Enlightenment myths and superstitions to enlighten the Enlightenment itself. So let's press on, then, and inquire of philosophers, theorists, and critics about what Mitchell describes as "the current interest in questions of material culture, objecthood, and thingness."[2] Perhaps one of these thinkers will help us to see things in a new light.

THE THING ITSELF

The literary theorist Miguel Tamen notes that not a few people believe that "certain properties of certain objects render those objects especially apt to *mean.*"[3] Must this always be an unenlightened, superstitious notion? (Speaking of notions, the Fortean anthropologist Lyall Watson has revived the Victorian term *notional* to describe any "inanimate object which...demands attention and exercises power over those people to whom it appeals."[4]) Exactly how does an object become a signifier of its owner's unsignifiable inner world? Are those of us who project our own ideas and emotions onto an object guilty of what enlightened types—including Catholics critical of primitive animists, Protestants critical of relic-fondling Catholics, and psychologists diagnosing pathological erotic-energy-displacing types—have tended to call "fetishism"? Maybe so. If fetishism is a force "guiding material objects into alignment with the magnetic pull of diffuse attractions and emotional cravings," as one student of psychoanalysis has defined it, then most of the contributors to this book are doubtlessly guilty as charged.[5]

But the pejorative is not just a religious or psychological one. Marxists have for a century and a half vilified "commodity fetishism," the phenomenon wherein an object manufactured for sale comes to seem alluring in and of itself, when its true value arises (or so they claim) from the human lives, labor, and relations that made it possible. Still, many enlightened Marxists—including Benjamin— nevertheless have found and continue to find particular objects, including commodities, irresistibly attractive. So let tenure-track radicals tell themselves that in collecting things they're liberating those objects from the tyranny of marketplace values; the fact is, even they sometimes find certain objects beguiling, or "notional." Why?

Where religion, psychology, politics, and economics fail, philosophy often comes in handy—but not in this case, except inasmuch as philosophy teaches us to ask better questions instead of seeking pat answers. From Plato until modern times, philosophers in the West have tended to downplay the importance of material things in favor of eternal and unchangeable ideas. The scholastic term *quiddity*—the essence of a thing—might appear to indicate a medieval interest in the meaning of objects, but instead it merely means "that which differentiates a thing from other things." What we want to know is why things *mean* differently. As for Heideggerians, existentialists, and phenomenologists, although they may talk excitedly of "the thingness of things," they always seem less interested in particular things than in exposing some supposedly concealed truth about *being*, by making a study of "the thing."

The emergence in academe, since the 1960s, of what has been called material culture studies—a theory-damaged offshoot of anthropology and archaeology—has led to the publication of innumerable anthologies whose titles sound promising: *The Social Life of Things*, for example, not to mention *Learning from Things, History from Things*, and *Material Cultures: Why Some Things Matter*. (Trade publishers have followed suit with one book after another explicating the "secret history" of every manner of quotidian object.) But such books tend to be reductionist: following the lead of more intuitive critics like Kracauer, Adorno, Lefebvre, Certeau, and Bourdieu, today's ham-fisted cultural studies practitioners brutally interrogate objects, demanding they cough up the dirty secrets of capitalist culture. "As they circulate through our lives, we look *through* objects (to see what they disclose about history, society, nature, or culture—above all, what they disclose about *us*)," admits Bill Brown, the editor of an unusually good scholarly anthology titled, simply, *Things*, "but we only catch a glimpse of things."[6]

One possible exception is the French philosopher and anthropologist Bruno Latour, who in recent years has insistently urged us to regard objects not merely as "matters of fact," in his formulation, but as "matters of concern." Instead of making things less interesting, by debunking the notion that things have meaning that can be discovered, he argues, enlightened critics ought to make things more interesting—by regarding every object as an association, a network, a gathering (*ding*, in German). Latour calls for "a multifarious inquiry launched with the tools of anthropology, philosophy, metaphysics, history, sociology to detect *how many participants* are gathered in a *thing* to make it exist and to maintain its existence."[7] If this sounds a bit abstract, I'd direct your attention to the many objects in this book that crystallize a relationship of some kind: the mussel shell that Matthew Battles found for his son, for example, or the sand clown given to Lisa Carver by her Satanist ex-husband, or the towel left at Sina Najafi's place by an ex–best friend, or Joe Keohane's cousin's uncle's cigar box.

There are plenty of other thinkers one could reference in this context, and there are also plenty of valuable contributions to this book that I've neglected to mention in this introduction. But let's conclude with Latour's injunction that instead of *subtracting* significance from things, criticism should *multiply* significance. Philosophers and theorists and critics, in fact, should take their cue from the contributors to this volume, who do much more than catch a glimpse of things. They single things out, linger over them obsessively, then share their excitement and bemusement, their embarrassment and joy with the rest of us. Charmed, as I said before, by such an engaging mode of making and discovering meaning, Carol and I wanted this book to be less a compendium of illustrated essays than a show-and-tell book. It's not an "object lesson," though; we haven't attempted to order or systematize

our collection in any way. Instead, we regard this book as an old-fashioned wonder cabinet: It's an assemblage of this, that, and the other thing. Its sole purpose is to invite you, reader, to participate in the enjoyable act of interpreting the meaning of things.

ENDNOTES

1 W. J. T. Mitchell, "Romanticism and the
 Life of Things: Fossils, Totems, and Images,"
 in *Things*, ed. Bill Brown (Chicago:
 University of Chicago Press, 2004), 242.

2 Ibid, 227.

3 Miguel Tamen, *Friends of Interpretable
 Objects* (Cambridge, Mass.: Harvard
 University, 2001), 130.

4 Lyall Watson, "Taking Things Seriously,"
 in *The Nature of Things: The Secret Life
 of Inanimate Objects* (Merrimac, Mass.:
 Destiny, 1992), 72.

5 Emily Apter, "Dan Graham Inc. and the Fetish
 of Self-Property," *The Lure of the Object*
 ed., Stephen Melville (Williamstown, Mass.:
 Clark Studies in the Visual Arts, 2005), 20.

6 Bill Brown, "Thing Theory," in *Things*, 4.

7 Bruno Latour, "Matters of Fact, Matters of
 Concern," in *Things*, 170.

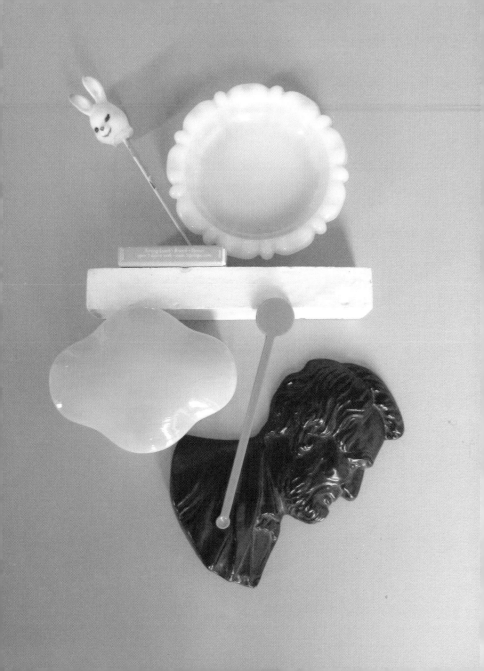

THIS IS A
JUPITER μ-30,

though I call it The Robot. It was found on Tremont Street in Boston, discarded by the Lord's & Lady's hair salon one garbage night in August 2000. My friend Neil and I noticed it upon leaving our office above the salon. If you're a guy and you see something even vaguely robotic on the street, you don't think; you act. I stuck my arm out and swept it away.

I've never seen a commotion on the subway like that caused by the Robot. Half the train insisted on meeting him. And yes, he's a "he." If you had seen the (admittedly inebriated) young women swooning over him, you would not question his masculinity. If somebody told you that the ultimate chick magnets were dogs and babies, somebody would be lying.

The Robot is a hairdo machine with five heat-producing lamps, two blowers, and a rudimentary computer console. He also has an adjustable probe-like appendage. When I plugged the Robot in, I was terrified by how quickly the heaters became red-hot. I like to speculate that the designer intended to mitigate the intimidating power of this contraption by imbuing it with human features, though the end product is fairly sinister.

When I was a child, science class documentaries and filmstrips foretold of utopias populated by clumsy, mechanical beings that would carry out our bidding. Now I have my own "robot," less productive than even a broken clock. And yet I don't think I'll ever be able to kick this thing back to the curb.

HENRY SCOLLARD

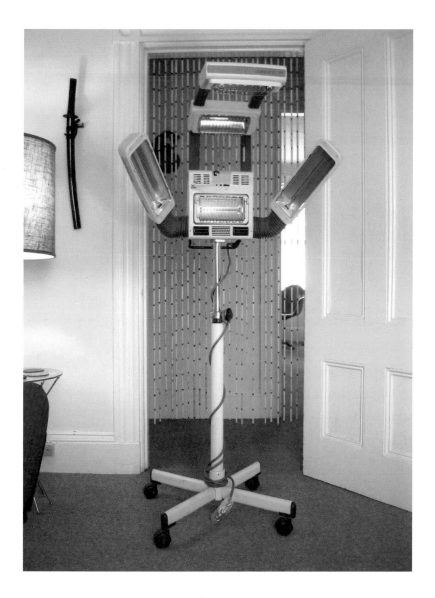

I BEGAN DOING MY "ZIPPY"
STRIP IN 1970.

In 1976, it started appearing in weekly newspapers. A year or so later, on a visit to the old Sacramento Delta town of Lock, about fifty miles from San Francisco, I had a "defining moment."

Lock had been occupied primarily by Chinese laborers in the nineteenth and early twentieth centuries. Faded Chinese ideograms were still evident on the storefront windows, though the place was largely abandoned and quite eerie. Many of the buildings on the main street were empty and decaying. I had a sudden urge for pork lo mein and headed for a nearby Chinese restaurant. I passed a demolished brick building.

Something gleamed in the rubble and caught my eye. I walked over and dug out an old soda bottle, in perfect condition. Lettered on the bottle was the word "Zippy" in a jazzy, colorful style. I finally had the perfect logo for my comic strip!

BILL GRIFFITH

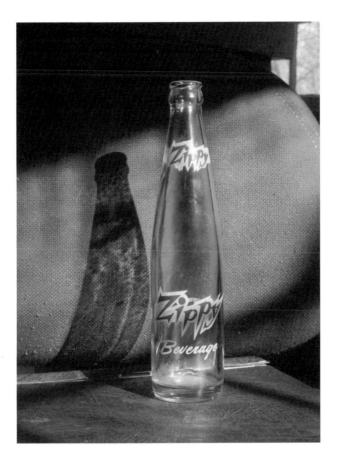

AN ABANDONED JOB
AND APARTMENT
WERE SEVEN HUNDRED MILES BEHIND ME

in Minneapolis. No work prospects and no home were seven hundred miles ahead on the West Coast. Somewhere around Santa Fe, I detoured to Arizona's Navajo Nation, where a friend was hosting a Native American Church Meeting the next day. I figured a night spent in a teepee ingesting peyote would clear my head of a growing panic and maybe bless my journey.

About twenty people—Navajos, a Ugandan, a dreadlocked reservation doctor, and a few Anglos—sat in a circle inside the teepee from a little past dusk till dawn. When I left once to pee, the stars were alive and close enough to touch. I could feel them on my skin. I looked back at the teepee; it glowed yellow-red from within; there was chanting. The desert stretched for a million miles beyond.

I spent most of the night watching the fire, and the pieces of my life that danced around in it. I'm from Arizona and was hit powerfully with how much of the land is inside of me, how much it makes me who I am. I stopped moving that night, stopped being afraid of my future. I realized that I carry my home with me; that the physical place that I'm from gives me grounding and perspective. I gathered the red earth just outside the teepee at sunrise, still vibrating from all that had happened the night before. I took it to remind me what I'm made of.

MARILYN BERLIN SNELL

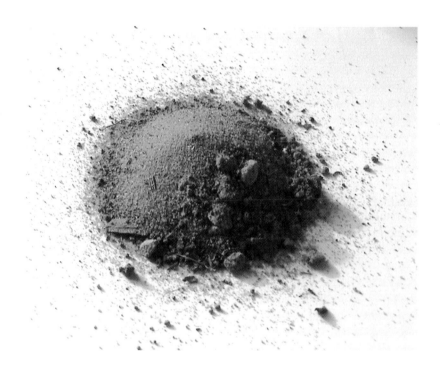

MY FAVORITE TOYS
WHEN I WAS A KID

were these cheap little rubber animals. For many, many years I played pretty much exclusively with them, acting out battles, domestic scenes, everything. The star of all these adventures was one special little yellow pig that I named Sunshine.

My enthusiasm for these unpopular toys was contagious, because my best friend Jeremy ended up getting hooked on them too. One day, while we were playing together at my house I noticed that Sunshine was missing. I was convinced that Jeremy had swiped her. But when I confronted him he became defensive and went home. I couldn't prove he had stolen her.

Eventually I entered puberty and I started to feel self-conscious about playing with toys. One day I packed up the rest of my little rubber animals and vowed I would never play with them ever again.

Years later, probably around 1989, we were having a particularly raging party at Jeremy's parents' house one night while home from college on winter break. I was poking around Jeremy's old room and lo and behold, what should I find but the pig he had stolen from me years earlier. Of course I promptly stole it back.

JAMES KOCHALKA

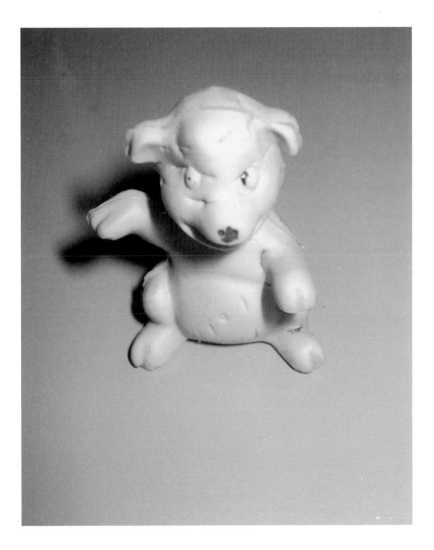

I'M PROBABLY GOING TO
HELL FOR THIS.

I've picked up hundreds of objects off the street and added them to my collection—letters, receipts, playing cards, pictures, no matter how dirty—but this was the payoff.

My boyfriend and I spotted this pair of white porcelain cupped hands on the sidewalk one day, propped against a trash can. The Hands (as I think of them) appeared to have been broken and carefully glued back together. We guessed they might have been a holy water holder; maybe the previous owner felt they were too sacred to put in the trash. We weren't sure how to use them, but we decided they needed a good home. Back at the apartment I washed the Hands and put them on the table.

For a few weeks they collected our keys. Then one night, over late-night cocktails, one of my guests asked for an ashtray. Instead of reaching for a small bowl to use as an ashtray, I saw the Hands: open, offering themselves. How clear it became! It's one of those things that makes visitors shake their heads, as in, "I can't believe I'm about to flick hot ash into these hands." I reassure them that this is what the hands were always meant to do.

DEB WOOD

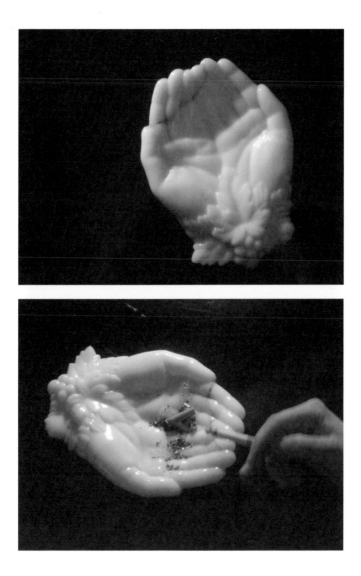

I USED TO PUBLISH

A ZINE CALLED

XYY, named after the fictional "criminal chromosome." It was filled with phony articles, intentionally unfunny cartoons, and interviews with people of questionable talent. The *Village Voice* once called it "*Boy's Life* for drunken mutants" and that's a pretty accurate description. Later issues contained a parody fan publication devoted to Christopher Walken. Our tongue-in-cheek slogan was, "There has not been a single film made in the history of cinema that wouldn't have been improved by containing a performance by the world's greatest actor—Christopher Walken."

Since then I've been lucky enough to receive a number of Walken artifacts from friends who know of my fondness for him. For instance, someone who'd worked on the set of *The Addiction* gave me an eight-inch long piece of clothesline, explaining that between takes Walken had rubbed it as though it were a holy icon.

In 1995, Robert De Niro opened his Tribakery restaurant in the TriBeCa section of New York. My friend Tracy and her husband stopped in early one weekend morning. When Tracy's bagel arrived she said to her husband, "What the hell is this?" He responded, "Ask Walken, he cooked it." She looked up to see the actor, dressed in cook's clothing, sheepishly averting his gaze from hers. After burning the bagel, he'd tried unsuccessfully to scrape off some of the blackness. Unable to eat it, Tracy took the bagel home and mailed it to me.

The bagel holds an honored spot in my office. From time to time, I open the envelope and stare fondly at its contents.

JOHN F. KELLY

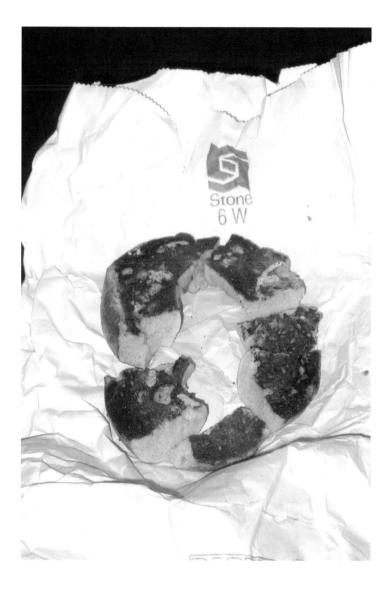

A SMALL, COLORED SAND—FILLED
GLASS CLOWN

that Boyd Rice—a magister in the Church of Satan who believes in joy above all else—gave me in 1994. He got it at Babyboomerama. I don't like clowns, I don't like colors, and I don't like Boyd. Yet I feel that it's my happiness charm. It just looks like it should bring happiness. And even though I haven't been all that happy since 1994, still I feel that it will happen, and it will be due in some small part to the sand clown.

I should probably smash it and change my luck by force. But look at that face. Could you?

LISA CRYSTAL CARVER

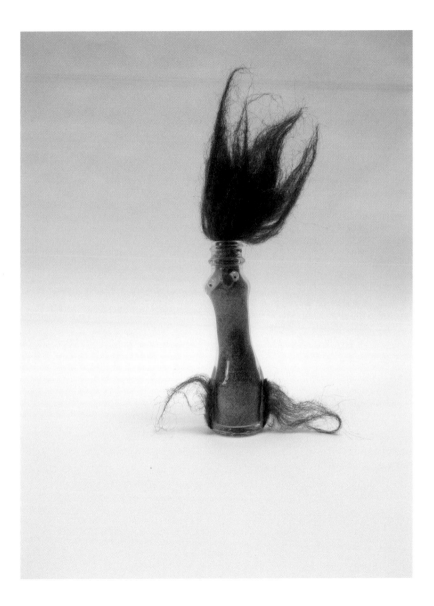

I COLLECT FIRST WORLD WAR ARTIFACTS,
BUT NOT BECAUSE
I AM ONE OF THESE GUYS

who spends his weekends reenacting battles. I have trouble even understanding why someone would want to act out the trench warfare of 1917. This was wholesale slaughter, industrialized and indifferent to individual heroics. Take a number and die. One might as well reenact the Spanish Flu.

I regard this French artillery helmet as a token of monumental disillusionment, a reminder of the greatest-ever failure of enlightened, middle-class, Christian civilization. This was the event where the official narrative—delivered by statesmen, preachers, and leaders of industry—ran so contrary to reality that faith in those institutions was weakened forever.

As it happens, my hometown of Kansas City is the location of a twenty-one-story-high World War I monument and a very large collection of Great War artifacts. As a schoolboy I approached these pieces with the form of patriotic reverence that the museum and the monument embodied. American wars were about freedom, I believed. And honor. And protecting hometowns. It was difficult for the idealistic young me to grasp that what really happened on the Western Front was that millions of brave men were ordered to die in an ill-planned and essentially futile conflict.

Today we are in the grip of a different sort of pro-war sentiment, a militarism in which the cynicism is readymade and the disillusionment is built-in, in which our GIs are always said to be betrayed by journalists and (liberal) politicians back home. Whenever some of that angry logic floats my way, I find it helpful to gaze upon that steel helmet and remember the lessons its wearer learned.

THOMAS FRANK

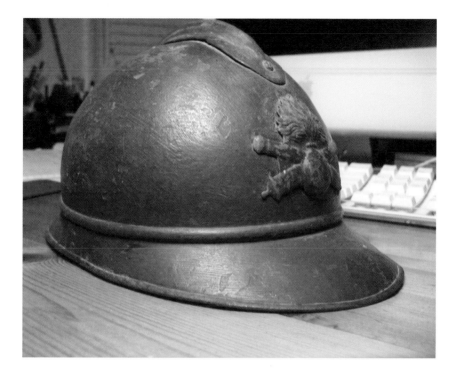

I SCROUNGED SOME

IRON-ON LETTERS

FROM THE DOLLAR BIN

at Sew-Low Fabric Discount Store in Cambridge, Massachusetts, one day while I was waiting for my mom at the beauty salon next door. Her hair was thinning from chemotherapy, and she was trying to make the best of it. My mom had lung cancer. She died eight months to the day after I made the shirt.

The shirt hangs in the doorway to a closet in my bedroom. Everyone asks where I got it, but nobody asks what it means. One visitor told me it feels like a warning. I suppose it is.

| JEN COLLINS |

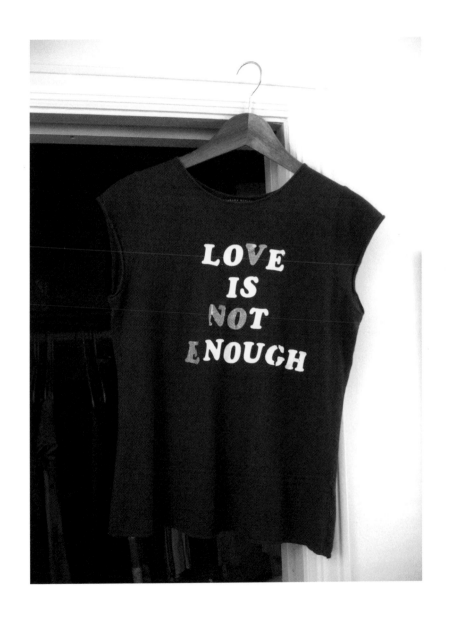

THIS ZIPPO LIGHTER,
ENGRAVED WITH
THE LA-Z-BOY LOGO

and emblazoned with an illustration of a recliner, was made in 1972 and fell into my possession over twenty years later when my then-girlfriend gave it to me as a birthday gift.

The gift was meant as a dig. The gift-giver was calling me lazy. I was tireless back then and could work for days without sleep. But maybe I was lazy. Or just LA-Z, an American form of despair. What I suspected then is that in the spirit the gift was given, LA-Z meant poor.

The LA-Z-BOY lighter became my talisman. Only once did it get away from me. I thought I'd accidentally left it in a bar. After a frantic, 3 a.m. return to the premises and a thorough, even crazed search, it turned out the person who'd borrowed it to light a cigarette had put it in her pocket. We'd had it with us all along. The LA-Z-BOY lighter turned up in another search once. That one was at the airport, where I learned the hard way that in the fight against terrorism lighters are no longer allowed on planes.

The Zippo lighter is a functional machine. When this lighter's practicality was combined with a symbol of American leisure at its most inert it became the coolest object in the world smaller than the moai of Easter Island. That it's now a potential weapon of terror only adds to its mana. In a forgotten Barbra Streisand comedy called *Up the Sandbox*, which came out the year my lighter was made, a group of black revolutionaries Streisand leads in a fantasy sequence use Zippos to light fuses that blow up the Statue of Liberty.

The woman who gave me the LA-Z-BOY lighter couldn't have known in those pre-9/11 days she'd given me a device that could blow up the world. Of such insults revolutions are made!

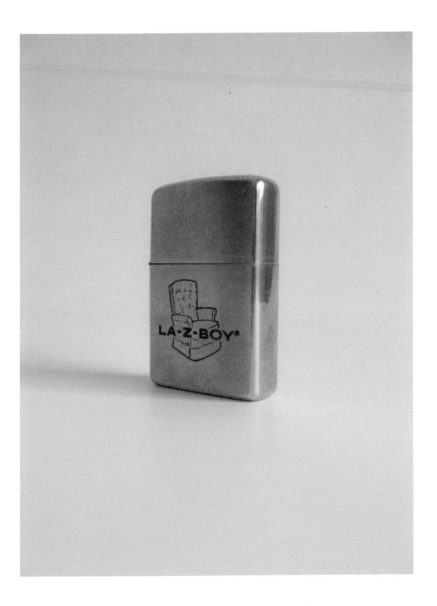

A TINY LITTLE

PINECONE.

It's less than a quarter-inch long but perfectly formed. I call it the Baby Pinecone because it seems so innocent and simple. I really love it. I picked it up in the fall of 2003 on a walk in the woods in upstate New York. It sits on the bathroom sink, and I look at it every morning while I brush my teeth. It makes me happy.

KELLY BLAIR

40

A FRIEND AND I WENT
TO MARRAKECH
FOR PRACTICALLY NO OTHER REASON

than because I had once seen a beautiful cocktail glass from the Hotel Es Saadi. I wanted my own. I loved its simple typography and palm tree logo and substantial heft. Of course there were other reasons we were in Morocco, but I confess to being vaguely preoccupied with the pursuit of this cocktail glass. However, once we got to the hotel we were devastated to discover the glasses were no longer to be found.

We asked a group of men working at the hotel about the palm tree glasses, and they shook their heads and said no, the hotel didn't use them anymore. We pleaded with the men while they stared at us.

And this is how I felt in Morocco, where almost every man we'd encounter would feel like an intimate, generous friend. Because the hotel workers seemed to appreciate the urgency of our search, and they dispersed in various directions and behind different doors and reappeared and left again as we waited in the lobby. Time went by. We tried to adjust to what seemed like inevitable disappointment. And then one of the handsome gentlemen arrived from basement storage or somewhere with a miraculous smile and four glasses wrapped in paper.

| CHIP WASS |

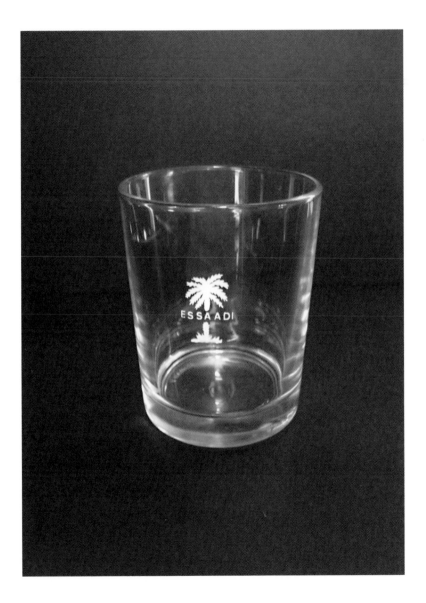

A FEW YEARS BACK

I TRAVELED TO ICELAND

WITH TEN FRIENDS,

ostensibly to attend a four-day music festival. On the third day of our trip we piled our duty-free-sodden carcasses into minivans to tool around the countryside. Although the tour plan we were following was a circular one, we got lost.

From the window we could see the surreal lunar topography—huge areas of the landscape comprised of lichen-covered lava boulders—and the many ponies, grazing the rolling hills amongst turf-roofed huts, had long and flowing manes like Charlie's Angels. Finally returning to the prescribed tour route, we arrived at a lovely frozen waterfall.

While warming up in the gift shop of the latter I scanned the souvenirs, wondering how it could be possible that gift shops, no matter how remote, offer the same crapulence the world over. Just then my friend Kevin crept up and presented this little fella on the palm of his hand: a tiny creature of indeterminate designation whose fluffy white body fur and quizzical expression struck me as the perfect embodiment of all the wonder and beauty of this strange island.

| RICHARD SAJA |

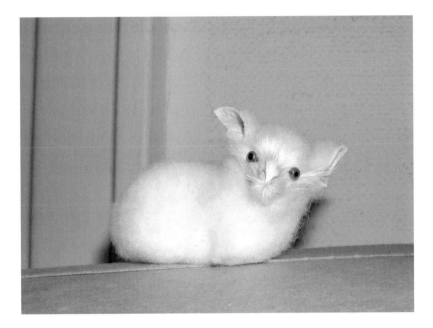

A GERMAN-MADE

PLASTIC PENCIL SHARPENER

SHAPED LIKE A TV.

Its 3-D screen shows a girl trapeze artist in black tights swinging over a circus crowd. I found it in 1992 in the top drawer of my assigned desk at the American University in Cairo, where I taught English. I used it maybe twice for its stated purpose and gave up because these things never work properly, and I hate pencils.

I'd been living in Egypt just under six months and had adjusted to the noise, the traffic, the poverty, the sheer number of people, and the utter lack of privacy. I regarded this little find as a symbol of my worldliness. So attached was I to it that when a freak earthquake hit Cairo, it was one of the things I found in my hands when I made it outside.

At the time, there was an ad campaign for Tetley Tea on Egyptian television featuring overdubbed footage of Hitler giving a speech. In Arabic, Hitler said something about how England had the ships, America the planes, but "we have the tea!" So my German pencil sharpener took on another meaning: Where the hell was I? What kind of Jew was I to be living in a country where it's as acceptable to use Hitler to sell beverages as it is for Americans to dress up as Lincoln to sell cars?

Today the pencil sharpener lives in my office, where I do not work as a teacher, or with anything remotely to do with the Middle East. It still has a piece of graphite stuck in it.

BETH DANIELS

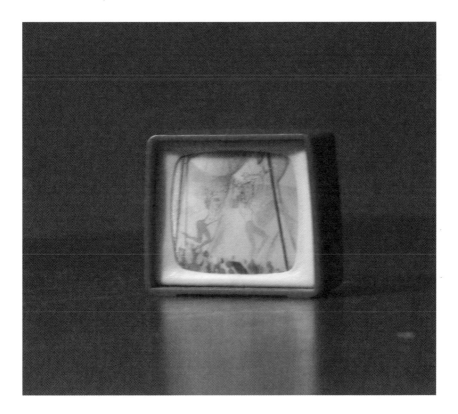

BECAUSE I'VE TRAVELED

TO SO MANY PLACES,

GUESTS EXPECT MY APARTMENT

to be crammed with exotic souvenirs. It's not. The majority of my curios are consigned to a single shelf. There you'll find, among other things, a giraffe tooth from Botswana and a vicious-looking barb from a Namibian acacia tree. Intentional or otherwise, there's a certain ghastly quality to much of my collection. Consider my pair of ceramic insulator pegs taken from the Birkenau concentration camp in southern Poland.

The remains of an electrified fence surround the perimeter of the Auschwitz-Birkenau complex. Walking through a deserted section of the camp on the first day of spring, 1995, I saw that two ceramic pegs—cylinders around which deadly wires would be wrapped, about the size and shape of salt-shakers—had broken from their posts and lay on the ground.

I was reminded of the time, on an earlier trip, when I'd pilfered a jawbone from an unearthed Indian grave in Peru. Once again the temptation to own something so absurdly profound trumped any notion of taste or decency. I pried both cylinders from the mud and tucked them into my backpack.

A decade later, I regret having taken them, but what can I do? They'd make terrible gifts, and throwing them away would be more blasphemous than stealing them in the first place. The only option, maybe, is carrying them back to Poland. In the meantime, there's something understandably evocative about these objects. Picking them up and rolling them around in your hands has a strange way of, let's just say, making you think.

PATRICK SMITH

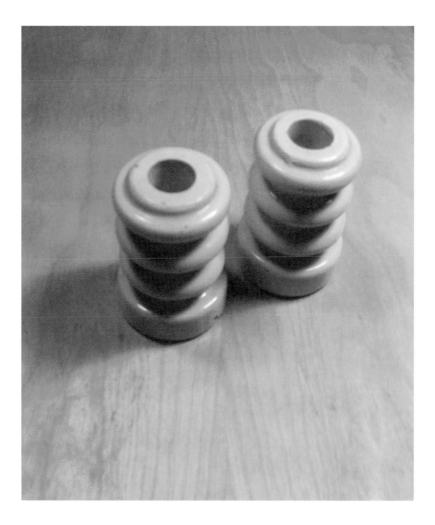

WHEN I WAS SIXTEEN

OR SEVENTEEN,

I had a huge argument with my father. For me, that fight was a turning point in our relationship; for him, though, it was just one of a series of disagreements with his nagging daughters. I had been clearing out the clutter that had been accumulating in our home since the untimely death of my mother years before. But then I discovered that my father—a renowned professor of archeology, history, and theology at Boston College—was trash-picking those very items and bringing them back inside.

I remember holding up an empty cheese-food box and arguing passionately against the item, saying it had no purpose. But my father wouldn't back down. He insisted that "Velveeta boxes are good boxes, well-made, and you can keep things in them." At that moment, I realized that if I couldn't even win the Velveeta box argument, then the arguments over the used typewriter cartridges, the orange juice container tops, and the bags of bags of bags—not to mention the rubber bands, napkins, little soaps, and twist-ties—were futile.

Flash-forward to twenty years later: I am helping my now-retired father unpack his belongings following his move to Los Angeles. I open a crate and sitting on top of its contents is a Velveeta box whose purchase-by date reads "1982." My father had used it to store cord. Twenty years and three thousand miles: He won.

BECKY NEIMAN

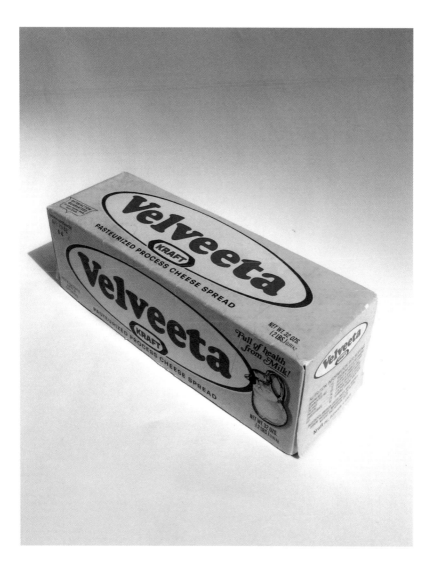

THE APHEX TWIN

BIG BOTTOM EXCITER

is one of several pieces of recording equipment that sit idly in the corner of my kitchen. As the name indicates, this twelve-by-two-by-two-inch box is designed to excite your bottom. During my DJ phase, that period of Clintonian prosperity and techno-euphoria when all I wanted to do was make "hot" music, the Big Bottom Exciter became a kind of talisman.

I inherited/stole the Big Bottom Exciter from a wealthy friend from college who got caught up in my fascination with beats. I was fortunate to have him as a collaborator because it turned out that "making beats" mostly involved buying equipment. It was in the pages of *Future Music* that we first laid eyes on the Big Bottom Exciter. I don't know if it was the allure of getting a whole creative process in a single box or the thrill of recognition that one of our favorite artists was named after this company, but we (he) immediately bought it.

We thought of the Big Bottom as a magic box, like the Echoplex in King Tubby's studio that he reportedly cured with marijuana to get his signature sound. After putting our music through it, our tapes sounded distorted and crackly, an effect we mistook for "hot." We covered the logo with duct tape so that no one would know the secret of our sound.

Our sound did not immediately find an audience, nor did it gradually find one. Eventually my partner burned through his inheritance and went to grad school, the Internet bubble burst, Bush got elected, and austerity returned to New York. But even today this box holds promise for me. I feel like if I could just hook it up to other things—my job, my relationship, the news, chores—they would instantly become more exciting and perhaps have bigger bottoms.

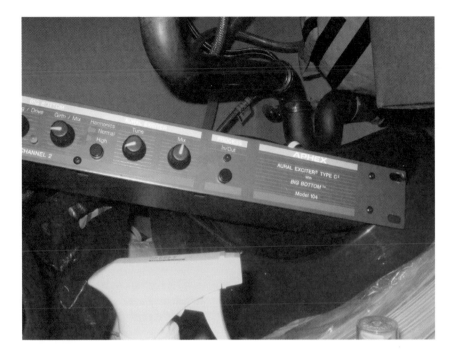

I'VE ALWAYS BEEN

SOCIALLY AWKWARD, BUT SECOND GRADE

was especially tough. My family had moved from Idaho to Washington for a brief stay, and at school I nibbled on pencil erasers and mostly kept to myself. David, a kid in my class, lived nearby and occasionally we rode our bikes together, making trails in the weeds of a vacant lot. Before we could become friends, though, the time came for my family to move home. The day we left happened to be David's eighth birthday. I'd been invited to his party, but my parents decided there wouldn't be time for me to go.

The moving van was packed and Dad was loading the family into the station wagon when I walked over to David's house and rang the bell. He came to the door with his mother, a noisy party in the background. I felt embarrassed, mumbled a goodbye, and turned to leave, but David's mother sent him inside to get something for me. He reappeared carrying a small, yellow sugar egg and handed it to me. I held it as we drove to Idaho. Over thirty-five years later, I still have it.

The egg—which is so delicate, and which has survived so long—speaks to me of the hope and the promise of friendship.

| RICK RAWLINS |

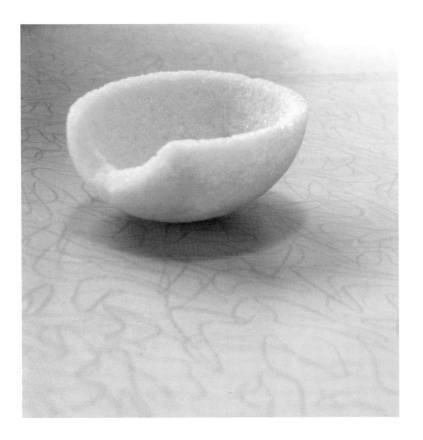

I GREW UP IN WOODSTOCK

WITH A HIPPIE

SINGLE MOM

who had her share of unfortunate boyfriends and the worst of them was Barry. He was an alcoholic who encouraged my mother to drink with him. When Barry was around, things felt chaotic and dangerous. Once he poured sugar into the gas tank of our red VW squareback and it never drove right again.

I was eight when I made this voodoo doll. I didn't believe in voodoo, but I did believe in dolls and my ability to control them. I found a featureless, legless leather doll and customized it with a mean face, a heart (I wrote "fake heart" where Raggedy Anne's heart is drawn), and the name Barry on the bottom. Although the doll lacked any pieces of Barry's clothing or hair, it felt infused with the power of my hatred for that man. I did stick some pins into it, but that made me feel bad for the doll. Just knowing that I possessed a voodoo doll of Barry made me feel like I had some sort of advantage over him.

Barry didn't stick around for very long. I hear that these days he maintains the best outdoor socks table in Woodstock. Although the "Barry" doll gives me the creeps, I've never been able to toss it.

| MEGAN CASH |

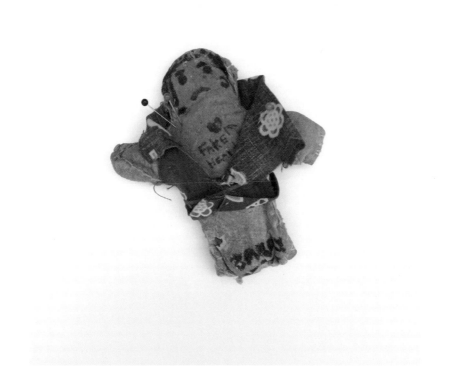

I FOUND THE SHELL

ALONG THE RIVERWALK—A

GLORIFIED OUTDOOR

food court—in San Antonio, Texas, while I was at a librarian conference a few years ago. A few weeks earlier I'd visited Maine and had returned with a seashell for my four-year-old son. When I was leaving for Texas, he asked me to bring him another shell. I despaired, telling him that San Antonio is too far from the sea. He told me that I should look anyway, just in case.

The conference was an awful affair—phalanxes of librarians with badges round their necks thinking about, but never quite, getting drunk. I stumbled about this scene for three days. On the last of them I passed over a footbridge when a glimmer caught my eye. In the elbow of the boardwalk and the shadow of pilings gleamed a compact ridge of sand. And on this sedimentary pillow rested a small shell, splayed open to expose its pearly innards.

It's a modest object, dun-colored, coin-sized. In life it sheltered a freshwater bivalve of the family *Unionidae*. Their method of reproduction is curious: the mother mussels release egg cases in the shape of drowned insects or tiny baitfish, attracting the attention of fish to whose gills, skin, and eyes the larval mollusks attach themselves. In time they detach from their hosts to become free-living mussels, leaving but a tiny scar as record of their obscure ontogeny.

I scooped up the shell and brought it home to my son, struck by filial prescience and the serendipity of small occasions.

MATTHEW BATTLES

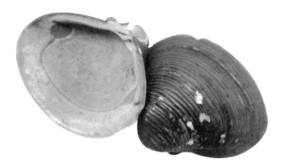

IN 1986 MY YOUNGER
BROTHER AND I WERE ACTING
AS DE FACTO CARETAKERS

of my folks' old house in Jamaica Plain, a crumbling fifteen-room Victorian perched next to the vast necropolis of Forest Hills Cemetery. Back then, I spent most of my time writing bad poetry and chasing girls. My brother occupied himself by fronting a punk band and creating giant papier-mâché sculptures made entirely of shredded pornographic magazines. To support this lifestyle, we took in boarders—a rotating cast of bohemian roustabouts, drunken writers, tantrum-prone painters and musicians, melancholic graduate students, lovers, and hangers-on.

One Saturday morning my dad pulled up in his pickup and deposited this ancient phone terminal on the front porch, explaining he'd spotted it for sale in a thrift shop for seventy-five dollars and couldn't resist. Within days, we were all hooked into the terminal. Each bedroom plus the kitchen was separately wired. Using a crank, one could alert each room individually. And of course we could all eavesdrop in an infinite variety of combinations. Whenever the bell rang in the hall, someone would bolt to the terminal: "Hello? House of Pain... To whom may I direct your call?"

Today, the dead hand of bourgeois renovation has swept the old house of ghosts, expunging its prior funk and whimsy. The terminal sits in a corner of my new home. I keep meaning to reconnect it but never get around to the task. Its oak cabinet and black Bakelite fixtures are still handsome. I've lost the operator's headset. Yet I'm convinced that were I to patch in right now, the faint voice riding the static would be my own younger self—randy, hollering, struggling to catch up.

KOSTA DEMOS

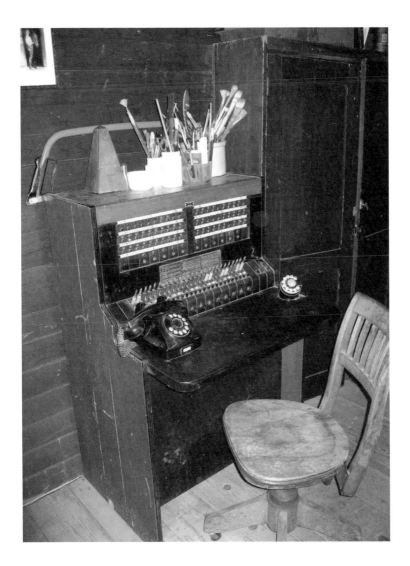

I RECEIVED A GRAMMY AWARD,

SEVERAL YEARS AGO,

FOR A CD PACKAGE I HAD DESIGNED.

Receiving a Grammy for a package design is like winning a Nobel Peace Prize for giving up a seat on the subway to an old person.

The ceremony for the lesser awards took place before the live television broadcast. As each winner was announced, we went up onstage, accepted a statuette, and then went backstage where we handed it over to be used for another winner. Some months later, I received one with my name engraved on it. I was particularly impressed with the laser-cut foam in which it had been packaged for mailing—a perfect negative image of the object it was supposed to protect. The foam demonstrates a lot of care and is done with beautiful simplicity. I like to call it the grammyfoam.

The grammyfoam is displayed proudly on a shelf. The award itself is in a box of odds and ends.

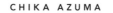

CHIKA AZUMA

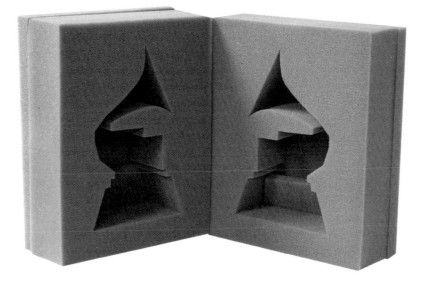

I BOUGHT THE GLASS
BEAR LAMP FROM
AN ANTIQUE SHOP

while on vacation in Cape May, New Jersey. The bear's passive posture and blank expression called to me. He pleaded to be removed from the shop's confines and be put to use, but the price tag was too steep. For a year I thought about the lamp frequently and even made a drawing of it. The following summer I paid the fifty-five dollars and carried the lamp home like a trophy. Everyone who saw it was as enamored as I.

I think the bear was originally an alcohol bottle. The shade isn't quite appropriate or in the best condition, but it works perfectly as a lamp because of the bear's totem-like stance and attitude. Even the sound of turning it on and off is special. I feel the bear is wise like an old tree. Its presence in my home is reassuring.

JOEL HOLLAND

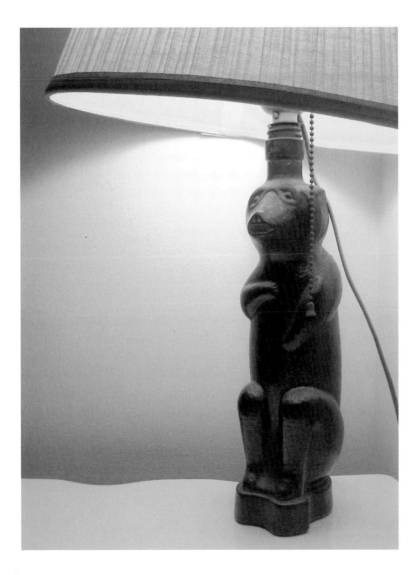

AS I WAS MOVING

INTO AN OLD BROWNSTONE

in Boston's South End, about ten years ago, the landlady was emptying out the apartment below mine. She asked if I wanted to take any of the things she was throwing away. I said, "Oh, the last tenant left all his stuff?"

"No, it was my son's place," she replied. "He died a few weeks ago in a car crash. I want his things to go to some use rather than just get thrown out."

I was a little spooked, but at twenty-one I was completely unable to process my own or anyone else's mortality. So I dove in and started to rummage. In among a bunch of drafting tools and art supplies I found a knob from an old car's dashboard. It was emblazoned with the word *lights*. I slipped it into my pocket. It occurred to me that perhaps the woman's son would have survived if he had been able to turn on the headlights of his car.

I have kept this little chrome knob as a good luck charm, sitting on my desk, ever since.

JULIAN HOEBER

I GOT THIS HORSE

AT AN AUCTION.

For a while there I dated women, and for a while I had a very cool, extremely hot girlfriend who sold stuff on eBay as part of her living, before everyone was doing it, and she'd go to country auctions for the supply side. When I first met her she was angling to buy an accordion she'd read about in an auction ad, sure if she spent less than six hundred dollars there would be a profit. I went to watch.

I first saw the horse at the auction preview. It was being ignored, dusty and collapsed on a box against a dark wall. It had thick, grimy strings attached to it and to a giant marionette wand. I didn't intend to buy it, but when it came up no one else bid, and I got it for forty dollars. My girlfriend got the accordion. Back in town we sat exhausted on the floor with our new treasures. Remember, we'd only just met. And you should know she'd intimately touched almost no men, ever.

We're admiring the horse, going on about its lovely detail and then one of us wonders just how detailed this horse is. We are being cheeky, neither of us suspects to find anything, but she's sitting closer to the horse and she slides a hand under its tail. The look on her face is not to be described. I was honestly shocked by it, and hurried over to check what she had found. Yes, no joke, this horse had generous detail.

It seemed funny to us that a couple of girls on their own would accidentally come home with a stallion so endowed. It would have been one thing if we had seen it first, but to discover it that way—inch by inch, if I may—well, we laughed until we stopped, if you know what I mean.

JENNIFER MICHAEL HECHT

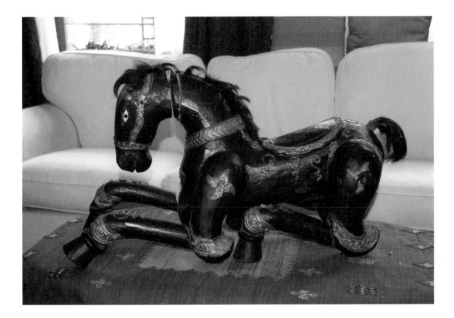

I FOUND JIG SAW JR.,

AN ELECTRIC SAW

designed and marketed for kids, at an antique show in western Massachusetts. The base was printed in bright carnival colors with illustrations of the sorts of things you could expect to make. Jig Saw Jr. was "safe, fun, constructive." Emerging from the base was a rusty, slightly bent, serrated blade.

It was so wrong, so enticing, and dangerous: a wholesome accident waiting to happen. There was the distinct possibility of tetanus. I'm sure that when it was manufactured it made perfect sense—weekends in the workshop with Dad, building birdhouses and bookends—but today it's just alien. I was smitten.

I talked myself out of buying the saw, though. Then, on the ride home, I started second-guessing myself, and after that I couldn't stop thinking about Jig Saw Jr. I talked about it—a lot, and to many people. I'd hook my finger a little whenever I described the blade. I searched for it in vain via Google and eBay. I pined. It took on a near-mythic import, this crazy object: the one that got away.

A couple of years later, my cousin Pete, who'd been with me that day, and his brother Jeff handed me a heavy cardboard box when we got together for Christmas. Jig Saw Jr.! They'd found it up in Maine. I keep Jig Saw Jr. displayed well out of the reach of busy little hands.

AUGUST MILLER

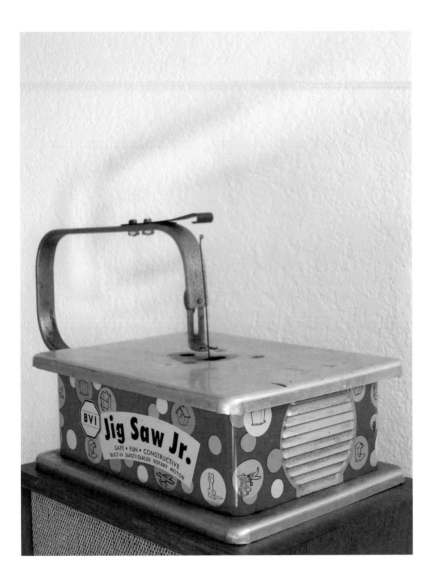

ONE NIGHT IN

down abandoned Hoboken streets to a Jersey City Waldbaum's under a rusty train trestle, where I bought a frying pan for sixteen dollars. It was as heavy as a bowling ball, unpitted and unseasoned. I was twenty-two, and this was the first thing I got for the first apartment of my own. With its scars and pits, the pan is now patinated with memory.

A paper came with it explaining just how it should be seasoned, but I didn't read it; I was depressed, and wanted something to cook a pound of consoling bacon in. I put the pan on the stove as soon as I walked in the door. Soon enough it turned black and took its permanent place in my life. I remember every obese, unseasoned pork shoulder in my lonely Tudor-themed apartment in South Bend, during my first year of graduate school; every uxorious omelet, in the early hopeful years of my marriage; and the time I cooked with it at a Jack Daniel's contest, hung over and high, with only high-concept dreams of elevating meat to art keeping me going. The morning of the day I wrote this, I cooked some sausages in it.

I haven't taken good care of the pan. The sides are craggy and chipped from where iron flaked away, or had to be scoured away because I left it to soak in the sink. And it has knife marks from where I tried, in an impotent fury, to pry out burned-in hash browns one night in 2003. I've tried to fill in the gashes by cooking with butter and bacon and potatoes browned in tallow; with fat, rich pork chops, and plump, unctuous chicken thighs; with splattering oil and sizzling lard. I'll go on trying. I want it to be smooth again.

JOSH OZERSKY

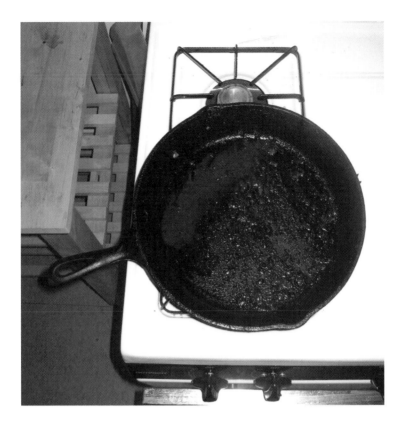

FOR SEVERAL YEARS,

I USED TO MEET A WOMAN FOR SEX

on a semiregular basis. It was a purely sexual relationship. She was married, and we knew only a handful of words in each other's languages. Some time after this relationship ended, I moved out of my apartment, and while cleaning up the bedroom I found, under the mattress and behind the bed frame, a large number of bobby pins that she must have shed over the years during the throes of passion. I collected all the bobby pins and put them in a box. Some people videotape their sexual encounters; to memorialize all my seasons of delirious sordidness I have only these pins, which a woman buys at Walgreen's for $1.29 a dozen probably, a suitably tawdry memento.

As you'll have realized, there's more to this. Looking again at the box, which was a Valentine's Day gift from this woman, makes it obvious that the purely sexual is no simple thing. First, the sexual isn't pure: $1.29-a-dozen bobby pins can be erotic. Second, the pure isn't sexual: the essence of sensuality is a metaphysical ideal that I tried to live. So holding on to this box is a complex ritual. Sure it's that old perverse and sentimental kick of proving that, through and after an affair calculated seemingly to brutalize both of us, I remained all too human, multifariously human. And keeping the box cuts the human down to size and puts it in its place, as into a museum are put the scratchy old bones of vanished private lives.

CHRIS FUJIWARA

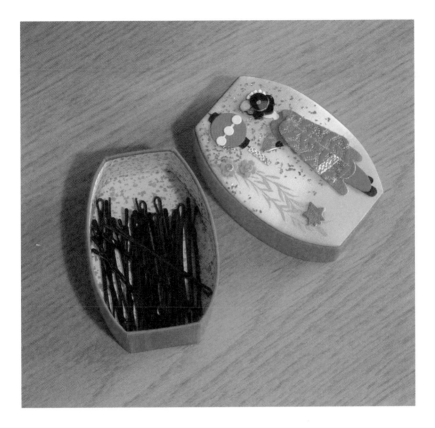

WHILE OUT ON A RIDE

IN JACKSON HOLE, WYOMING,

I TOLD THE WRANGLER

about riding a bike all over Manhattan and she questioned my sanity: "It's so unsafe, so unpredictable there!" Just then, there was a huge cracking noise, like a bomb exploding right in our ears. The horses ran away with the novice riders. Then I saw the culprits: a beaver couple that had dropped a big aspen across the stream we had just forded. They were laughing at us, I am certain.

After we got heartbeats to normal I picked up this beaver stick—a small branch with all the bark carefully chewed off. There are tooth marks meticulously covering the entire stick. I kept it because it makes me laugh, both about the humor of animals and how comfort and safety are such relative terms.

WICKHAM BOYLE

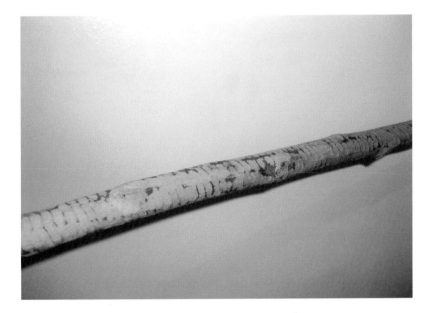

THERE IT WAS:
"THOUGHTS"!

How could I not have seen it before? I was sitting at the dining room table in my aunt's house in Massachusetts when I looked up and noticed this needlepoint sampler for the first time. Holy shit, I almost said out loud. Had it been there for a long time? When did my aunt make it? What was she thinking when she made it? What could it possibly mean?

I have the same inner conversation every time I look at it. Thoughts? Is it thoughts in general, or specific thoughts? Thoughts about a person? Memories? "I'm thinking of you"? Was my aunt trying to express the feeling of going through the mental process of deciding what needlepoint pattern to make next? The sampler's vagueness plunges me into philosophical confusion. The mystery of it is what attracts me, but it's also what bothers me. You think thoughts, but how often do you think *about* thoughts?

My aunt could tell how much I liked the THOUGHTS sampler and a few months after I spotted it she gave it to me as a gift. I took it home and hung it on the wall. Sometimes I would stare at it, and I'd get frustrated every time. Other people who came over and saw it reacted the same way.

My aunt never explained what she meant by THOUGHTS, and I didn't think it was the kind of question I could ask her. Eventually I had to put the sampler away because it made my head hurt. The idea of my aunt making a picture of the word *thoughts* in needlepoint amazes me. I never would've thought of it. It's the perfect combination: profound expression and humble craft.

CAROL HAYES

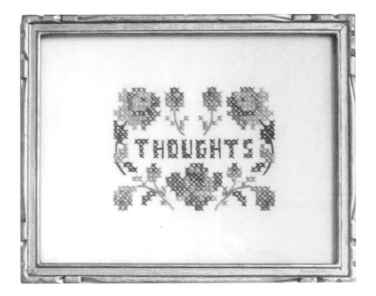

I'VE HAD THIS
CIGAR BOX SINCE
I WAS SEVEN.

The crude black marks are where the name *Nolan Ryan* used to be written all over it. Nolan Ryan was my hero when I was a kid; I used to keep my formidable collection of NR cards in there. The box came from my cousin's uncle: an abrasive, tragic, Willy Loman figure who smoked fancy cigars, carried around a creased photo of Red Sox legend Carl Yastrzemski in his pocket, and never missed an opportunity to talk about how "me and Carl went fishing." You'd ask, "Carl who?" and then listen to the whole story.

In the end he died of three separate drinking- and smoking-related cancers, and left behind a staggering amount of pornography. My cousins found the lode in his attic after the funeral. They tried to sneak it out while their aunt was away, but she came home early and wanted to know, understandably, what was going on. My cousins stood there struggling with the huge boxes, trying to cook up an explanation, before my older cousin finally put his down and said calmly: "It's porn. It's like two hundred pounds of porn."

She had no idea.

I crossed out all the *Nolan Ryan*s on the box when I decided, maybe around fifteen, that baseball cards weren't cool. Nowadays it functions as an appropriately seedy repository for spare change and prophylactics.

JOE KEOHANE

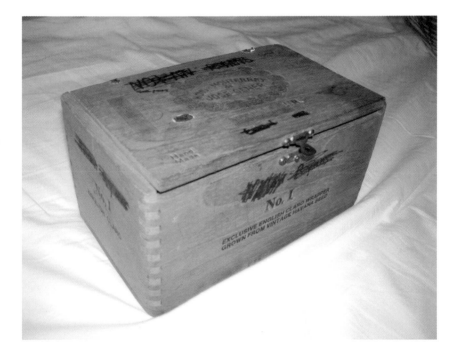

I LOVE
"UGLY-PRETTY" THINGS.

This is my term for objects that are unsophisticated, maybe odd or silly, but pretty to me. Most ugly-pretty objects date between the years 1958 and 1966: Annette Funicello was ugly-pretty; today's supermodels are not. The "Made in Japan" era was a golden age for ugly-pretty toys: Animal toys with their tongues sticking out, for example, are my favorite. From the disregarded corner of thrift stores, from abandoned boxes at estate sales, ugly-pretty toys beam their message to me: "Take me home!"

I found this inflatable doll at a thrift store in Japan about ten years ago. What a girl! Besides her heavy makeup, she has large polka dots on her skirt—even on her face. (I'm a big fan of polka dots.) The more my friends said she was ugly, the more I loved her. She is perfectly ugly-pretty. After moving to America and learning about Wonder Bread and its fabulous, optimistic polka-dot logo, I named her Wonder Girl.

Wonder Girl is my lucky charm. I brought her to the delivery room when my daughter was born. My daughter now thinks Wonder Girl is alive and her best friend since she was there from the beginning. Maybe her first word will be some inflatable squishy sound.

NAOMI CHICHIWAN

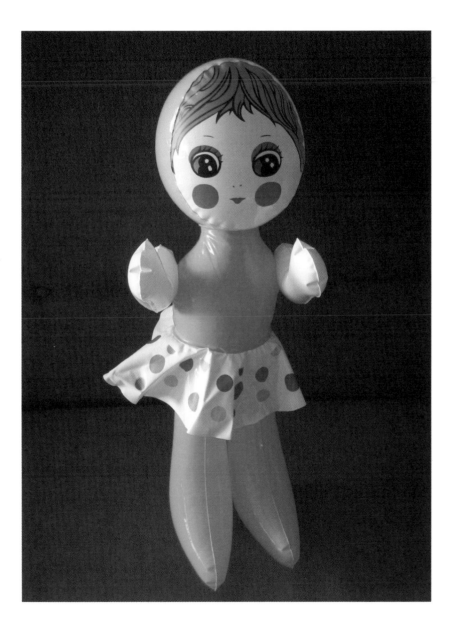

SOME YEARS BACK

I SPENT AN AFTERNOON TRESPASSING

my way through one of the abandoned steel mills of Youngstown, Ohio. There were all the usual ghosts that come with industrial decay: the rusted machinery, the lockers with clothes still hanging in them, the clipboards with work orders that were never carried out. Every dusty artifact was an untold story, and I was overwhelmed by thoughts of the hundreds of people who'd built the place, the hundreds more who'd worked there, and the futility of having the product of all that labor just sitting there in varying states of rot and deterioration.

I wanted a keepsake, but I didn't want to be ghoulish. After all, this place was a grave, and gravesites are to be respected. Then I looked overhead and saw a series of light bulbs. Instinctively, without fully realizing why, I began unscrewing them until I found one whose filament appeared to be intact. I took it home, where I screwed it into a live socket and discovered it still worked—a small living piece of a huge industrial corpse.

I still have the bulb, and it still works. It's stored in a closet, but every now and then I take it out, screw it in, and use it for a day or two. In my overly romantic, anthropomorphizing way, I like to think it enjoys these occasional opportunities to fulfill its intended function—you know, production for use and all that. Eventually, of course, it will burn out, but that's OK. I never expected to keep it alive forever; I just wanted it—and, by extension, the rest of the steel mill—to have the dignity of a natural death.

PAUL LUKAS

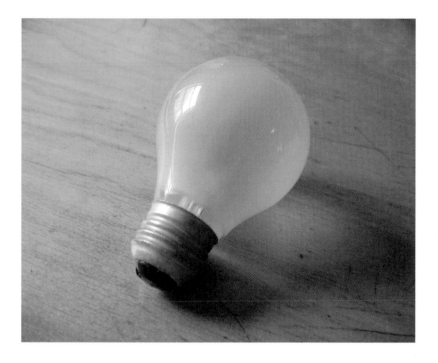

OUR SUNROOM COUCH
WAS THE SCENE OF
BATTLES AND PARTIES,

the stuff of forts, the extra bed, the TV couch. But one corner belonged to Mary Grace: Mom, not only to her nine children but also to scores of others, including her children's friends and their friends.

When she wasn't feeding us, doing ten loads of laundry a day, starting a new school, running her own business, catching a blues band at a local bar, or marching for civil rights, Mom was on the couch resting her bunions, drinking thin black coffee, smoking a long-ash Pall Mall, or enjoying an icy Coke with an egg salad sandwich. The television was always on but she could read the papers, do the Twins scorecard, tape a *Columbo* re-run, and pay attention to us at the same time. Late at night while everyone slept she would find some time alone there playing solitaire with a Manhattan. The woman slept very little.

After many hard years of service, the couch's time ran out. It was beat up pretty bad. My brother Paul called: "Dad's buying Mom a big easy chair, the couch is being tossed. What do you think?" I asked him to saw the arm off, the one with Mom's patina. The one with the cigarette burns. The dog-chewed, ketchup-stained, Miracle-Whipped, pawed-by-a-thousand-little-hands arm. He brought it to New York where it is screwed to a wall once in a while. Her grandchildren hang around it, leaning on it as though Mary Grace were there.

DAVID SCHER

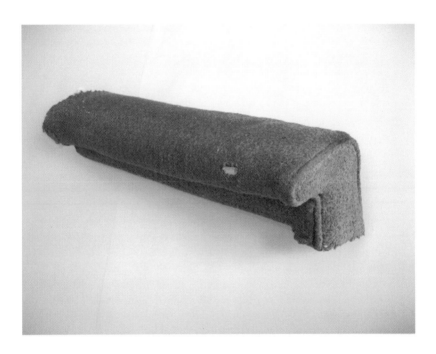

BAUDELAIRE'S DEATH MASK
GATHERED DUST FOR YEARS

on top of a tall bookshelf in the front hall of my childhood home in Jamaica Plain. When I was a teenager I scaled the shelf one day after school looking for a switchblade that my father, a minister, had once mentioned having confiscated from one of his parishioners. No such luck, but I did appropriate this chipped, tarnished plaster object and hung it above my bedroom desk. It has grimaced sightlessly down upon every desk I've had since.

I've kept the death mask for a perverse reason: Because it's the sort of thing one used to notice in the background of photographs of pretentious writers working at their desks. Under the mask's influence I once spent two impoverishing years slaving over a book about Baudelaire and other thinkers. Like Walter Benjamin, whose *Arcades Project* started out in more or less the same way, I couldn't finish it.

The poet and novelist Fanny Howe used to own my father's house; until recently I believed it was she who'd left the mask there. But now my father tells me not only that he doesn't know where we got it but also that he never told me whose face it was. After a little research I discovered that it's actually a life mask of Keats, from the original in London's National Portrait Gallery. So why did I think Baudelaire?

Perhaps I was influenced by a passage from one of Howe's novels that I read as a teenager. The protagonist, an ex-political activist turned poet, is asked by a former comrade, "On your death bed, will you be able to say, 'I helped the poor in their struggle for justice?' Or will you only be able to quote Baudelaire?" It's an unfair question, I know. But it's one that still haunts me.

| JOSHUA GLENN |

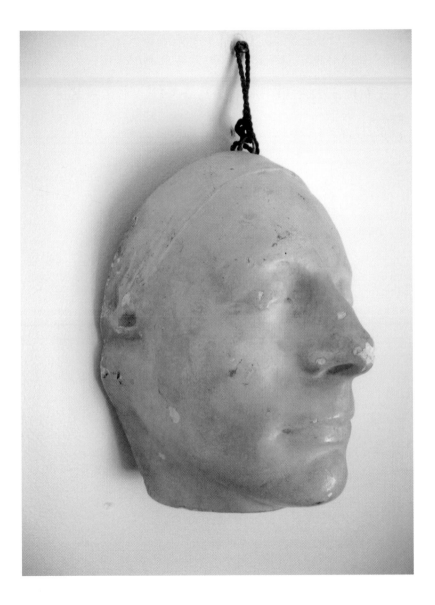

IT WAS A RELENTLESSLY
HOT SUMMER
AND EVERYWHERE AROUND ME

people were enjoying themselves. But I was wandering aimlessly, alone in a foreign land, numbed by confusion that was suffocating my brain. In fact, I was on the verge of a collapse; something that had been slowly creeping into my system over some time was soon to consume me.

I tried desperately to act normally, even though I could hardly see the faces of the people around me: They were just passing shapes. It occurred to me that if I entered stores and touched the merchandise inside, I might be able to connect to the reality within which those faceless shapes moved. The plan worked, at first anyway—and it was while I was keeping myself together in this fashion that I came across the Green Man.

He appeared in my hand, as if transported from another dimension, while I was in a stationer's shop touching pencils, sharpeners, and erasers. The Green Man was unconnected to anything else in the place, I discovered, and the store workers were unable to identify it. They sold it to me anyway, making up a price. But I didn't care. I had to have it. This tortured little being had connected with me. It looked like how I was feeling. Pain was reeking from its distorted, mutilated body. I wanted to help it, and held it gently so as not to hurt it anymore than it already was.

Oh Green Man, I feel for you.

MARIA KOZIC

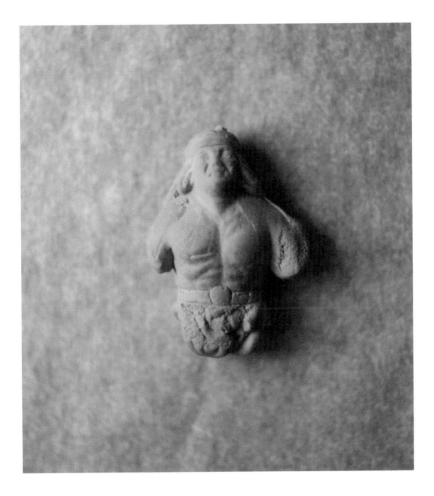

THESE ARE MY FINGERNAILS.
I REALLY THOUGHT THERE'D BE MORE OF THEM

by now—it doesn't look like much. I've been saving them since 1995. I originally wanted them for a photograph, but now they've kind of become their own thing. They really are all here, I've never missed a cutting. When I go on vacation, I try to cut my nails before I leave, or worst-case scenario is that I bring them home in a Ziploc bag or something.

I'm thinking maybe when I've got enough, I'll put them in a large vitrine and see if I can get them into the Whitney Biennial. No one else could come up with this on such short notice.

AMY KUBES

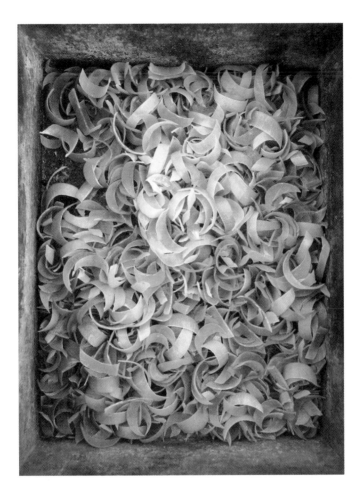

THE INSTANT I SAW HER,

NAKED ON THE WEED-CHOKED GROUND,

I WANTED HER.

There was nothing else I really wanted from this garage sale. Not just any naked lady, the Sweet Sue Torso, as her instruction sheet called her, was educational. Her front came off to reveal her internal organs, each packed puzzle-like into her abdominal cavity.

I picked her up and caught the eye of the woman having the sale. Then I realized it was L. She and her boyfriend J had worked with my husband, about fifteen years earlier, painting sets and making props for movies and TV. She was fun then. After L and J broke up, though, we heard things: she'd gone kind of crazy. For a while, she called J repeatedly, alternating wild accusations with begging to be taken back. Then she was the single mother of twins. I'd seen her once in a grocery store, looking like a wreck, like a different person.

L looked better now, but she was living in a ratty duplex on a busy street in the same neighborhood in Los Angeles. Time and two children had changed me too. I looked her in the eye, and she didn't recognize me. I didn't want her sad story, anyway. I only wanted her naked lady. When I asked her where the lady had come from, she said, "Uh... I'd rather not say." That's when I knew she'd pinched it from some film set she'd worked on. I bought the stolen merchandise anyway.

When I got my naked lady home, I found out that she would be more educational if it wasn't so hard getting her organs back inside of her. So I keep her closed up. She stands on the mantel in our living room, serene, above it all. She doesn't need to spill her guts.

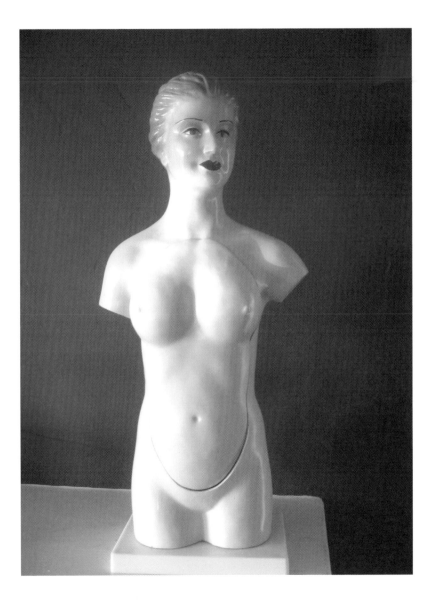

"YOU ACT AS IF

I'M THROWING AWAY

A FAMILY HEIRLOOM!"

This is what my boyfriend says every time I stop him from throwing one of my empty glass jars into the recycling bin.

A few years ago, I started collecting jars. Not antique jars but jars of pickles, jam, mustard, capers, maraschino cherries. I was inspired by my grandfather, who recycled food jars to store his nails, washers, nuts and bolts. A new jar calls out to me every time I shop at the grocery store. I take it home, and after we've eaten its contents, I gently wash it and remove its label by soaking it in hot soapy water.

Of the dozens I have collected, this one is the most beautiful, the most divine. I don't remember what this particular jar held, and the only clue is some cryptic marks surrounding the number seven on the bottom. The diameter of the jar's mouth, the gentle rising threads, the width-to-height-to-depth ratio of the factory-made molded glass, its breathtaking simplicity, combine to create a sensation in my mouth, a taste in my throat, that I can't make anyone else understand.

At the end of the day when I get home, I enjoy looking at its quiet, transparent beauty.

JENNIFER ALDEN

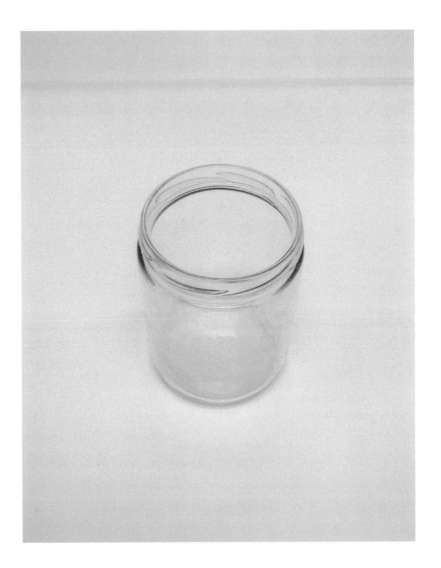

I BOUGHT THE FIRST

CUPCAKE AT A BAKERY

in Boston's Roslindale Square. It was around Halloween 1988, and there in the display case was a cupcake topped with a large blob of orange frosting with a pumpkin face and a green icing stem. I was fascinated by the appalling ratio of frosting to cake, and I loved the design. Out of aesthetic admiration and nausea I was unable to eat it.

Of the thirty or so cupcakes I collected over the next six years, my favorites were the ones where the frosting played a crucial role in the overall presentation: the Easter basket, which had three jellybeans nestled in a bed of straw-colored frosting with a pipe-cleaner handle; the steamship cresting a wave of blue frosting; and best of all, the white, wintry Christmas diorama in which Santa skied past a tiny pine tree.

After a few weeks the cupcakes would harden, crossing the line from confection to decor. I kept them in a display case, and although I did notice them sweating on the muggiest days of summer, they always returned to their petrified state. When I left Boston in 1995, I gave the cupcakes to a friend who was living in a basement apartment, where a flood swept away the collection. (Probably they just got waterlogged and were tossed out, but I prefer to imagine them being swept away.)

| MIMI LIPSON |

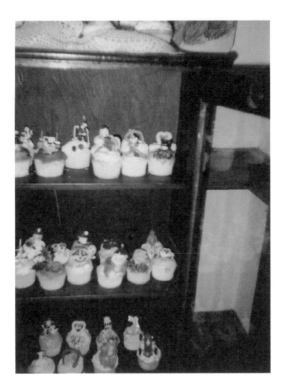

I FOUND THE MARBLE
ON THE STREET ONE DAY
ABOUT SEVEN YEARS AGO.

There isn't anything particularly special about it except that it happens to be broken. There's a small chunk missing which serves to flatten out the bottom. I put it in the pocket of the jacket I happened to be wearing. The marble stayed there for four years. When I got rid of the jacket recently a new home had to be found for the marble. But although I tried several jacket options, none seemed right.

Around that time, I took a ceramics class at the local community college for fun. I was pretty terrible at it, and the piece that turned out to be my favorite was just something I ripped off a spinning clump of clay to mitigate my mounting frustrations. I probably should have thrown it away, but instead I glazed it and fired it. There was one flaw in the piece, a crack at the bottom of the inside of it. It pleased me to no end when I placed the broken marble into the pottery that the two flaws fit together perfectly.

The two objects live happily coupled on the nightstand next to my bed. Much to my dismay no overnight guest of mine has yet asked about this odd pair, which perhaps explains why I remain single.

JENNIFER TILL

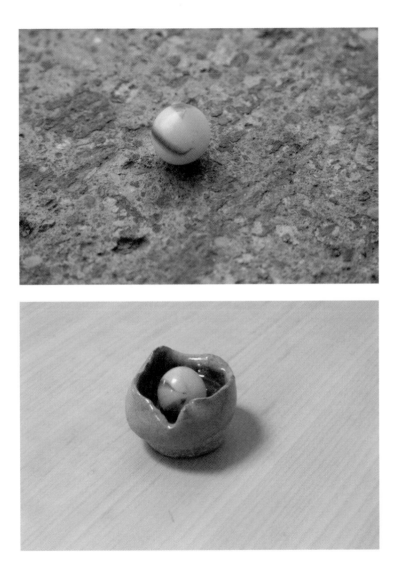

WHEN I WAS SEVEN

I LIVED NEXT DOOR

TO AN EXOTIC OLD WOMAN

and she gave me this Santa. In hindsight, the woman was old and probably a cardiologist—only exotic in the sense that she was very educated and lived next door to us, the unruly Catholics with seven kids. One year she invited the bunch of us over for a little Christmas party, which seemed incredibly fancy to me. There was a long table with a white tablecloth, and cookies that were unlike any I'd ever had, flat with a sickening licorice taste.

After the party the woman gave me and my brother identical Santas, except that mine had a gimpy leg and it wobbled, which seemed right at the time because I saw myself as a victim.

GREG KLEE

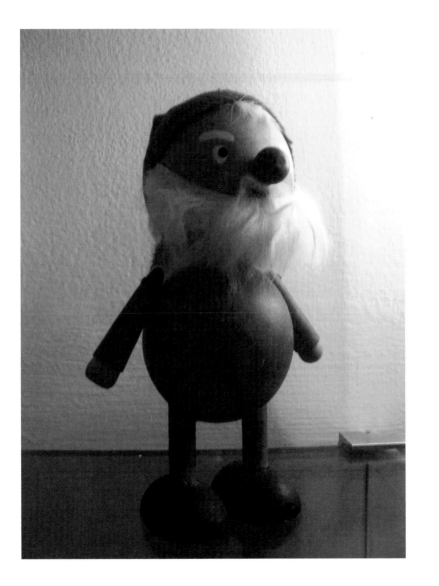

AN ARTICHOKE SAT

ON OUR KITCHEN WINDOWSILL

FOR MONTHS, SOME YEARS AGO.

At first, it was ugly and disgusting and kinda gooey, and guests would say "ick." Then it slowly dried out, changed color, became something else altogether. I've now had it for ten years.

I think it's rather beautiful. I keep trying to use it in a design project, say on the cover of a book. I have photographed it numerous times and created design prototypes featuring this artichoke. They never sell: others do not seem to appreciate the intrinsic beauty of this thing.

Over time it has become more fragile, and I worry that it will break. So it sits, carefully placed, in my bookcase next to some Roman pottery a couple of thousand years older. No one ever touches the older, more fragile pottery, of course. But many pick up my artichoke.

WILLIAM DRENTTEL

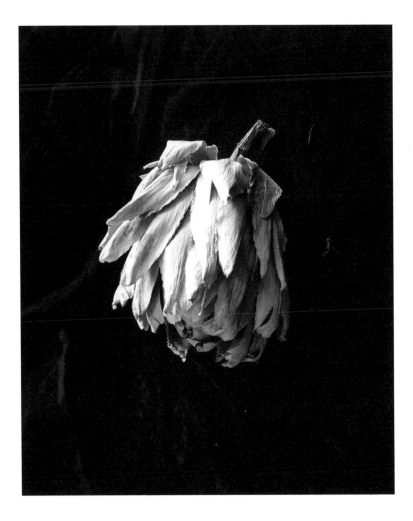

I WAS WALKING
HOME FROM A CLUB
IN NEW YORK WITH SOME FRIENDS

around 2:00 am. I had to work the next day. Near Union Square I saw this large Pan Am Worldport terminal guide leaning against a dumpster. We all talked about taking it, but because it was so heavy, we left it behind. I tried to change the conversation so my friends would forget about it. But once I got home, I grabbed my skateboard and rode it back to the dumpster. I balanced the sign on the skateboard and rolled it away.

A few blocks later, a tall woman dressed in black asked if I needed any help. I quickly said no, thanks, and kept walking. I've since regretted doing so. Anyone who would offer help to a stranger wheeling a large sign down a deserted street late at night could have been a good friend.

I've moved the sign from New York to various Massachusetts towns and most recently to Seattle. It would make a great worktable or dinner table, but out of laziness I've just kept leaning it against the walls of my apartments. When I lived in North Adams, Massachusetts, my father asked if I remembered when we found it together. You were not there when I found the sign, I told him. He still he insists he was.

JESSE MILDEN

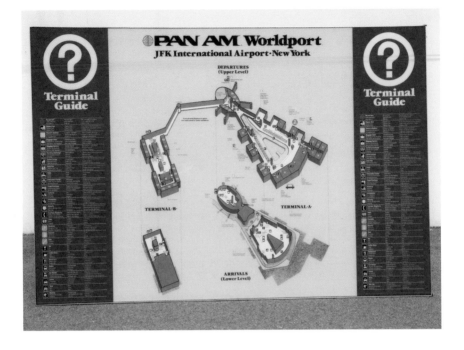

EVERYONE WHO SEES THIS
COMPUTER CABINET

has the same reaction: "What the hell *is* that thing?" "Oh, just my stereo," I reply. It's about five feet tall and three and a half feet wide with *Star Trek*-era modern brushed aluminum and aquatinted glass doors that weigh about fifty pounds each. A metal label identifies it thusly: Control Data Corporation Peripheral Controller.

I acquired it at a surplus auction at the University of Texas in 1985. I was told the unit had cost a quarter of a million dollars; I got it for ten dollars. I dismantled it, saving all the hardware and labeling the heavy panels, and spent the next ten years hauling the pieces from place to place. Finally, in 1996, I slowly reassembled the thing. In an attempt to justify all the space it took up, I removed most of the circuit boards and modified the interior to hold my stereo and records.

I actually hate modern design—my tastes run to the Victorian and antique—and I'm not too crazy about computers, either. So why am I so fond of this uber-white elephant? I suppose it's a souvenir of my abortive engineering career and evidence that perhaps I was only interested in the historic and aesthetic aspects of technology all along—I was never going to be happy writing software or solving differential equations. It also reminds me of visiting my dad's office as a kid, where there were rooms full of similar IBM computers, and my sister and I would spend hours typing out insults on punch cards to amuse ourselves.

Most people have never seen anything like my big, obsolete, all-transistor pre-integrated circuit shell of a computer. Now it's another antique, an artifact that reminds me of a time when the future seemed both exciting and foreboding.

| JOHN KEEN |

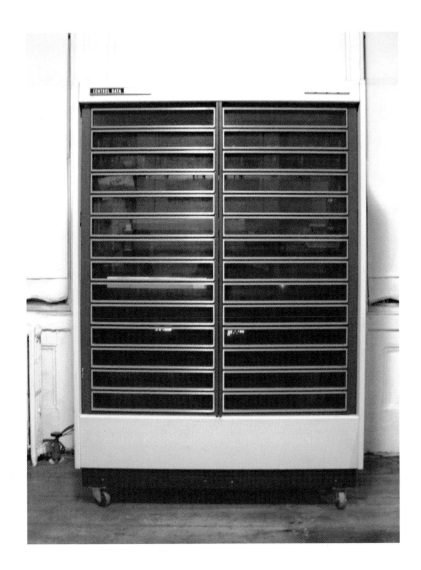

IN 1978, WHEN I WAS DOING
JAZZ SHOWS ON KRAB,

the local listener-sponsored radio station in Seattle, I had a frequent, mysteriously charming caller. One day I told him to come visit at the station, and in walked a moving assemblage of scavenged motorcycle clothing and gear on a skinny, grinning, scraggly guy. Thus began my tortuous romance with Jamie.

The epitome of someone who could never work for "the man," jobless Jamie, who drank too much, lived in the basement of a wealthy former schoolmate and girlfriend still beguiled by his wistful, little-boy-lost appeal. He spent a portion of every day riding his BMW motorcycle to the Goodwill to search for discarded junk to remake into the beautiful objects they were meant to be, all the while badmouthing the country that threw away so much stuff. In a culture that rewards monetary achievement, there was no place for someone who could feel the sadness of a broken fork or cup. I don't think I ever saw anything new in Jamie's home; it was a museum of reborn objects that he generously gave away to his friends.

Once in a while, though, a discarded object that needed no remaking—because it seemed to possess a cosmic secret about our culture—also made it back to Jamie's place. This giant replica pill, a pharmaceutical company's promotional ceramic paperweight, was one such object. I love the pill both as a crazy, beautiful thing and as a memorial to Jamie, who eventually shot and killed himself with a homemade gun, in his basement workshop, long after I had moved on.

HELENE SILVERMAN

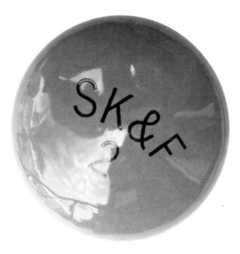

MY FRIEND DAN

CAME FROM A TOWN

in Northern Ontario famous for the fact that some Jesuits were tortured and killed there while trying to convert the local Indians to Christianity. When we were in college, Dan visited the shrine and had a mystical experience. I don't know what his vision was, but it sent Dan over the narrow edge from talented philosophy student to genuine madman. He still came to class, but no longer made any sense, even to the Hegel professor.

For years afterward I would see him on the streets of Toronto, trying to make a living from inside his dementia. He sold frozen steaks out of a cooler. He sold little glass animals from a baize table unfolded in front of a department store. One day, as I was standing there talking to him, a concrete-canyon gust of downtown wind picked up the table wholesale and smashed his entire kitsch menagerie into fragments on the sidewalk.

I bought this Baia Dual 8 Film Editor from Dan the next time I saw him. I gave him three dollars for it, no haggling, and hoped he would use the money to get a shower because it was too late for the teeth. The bulb on the editor is still good, so I use it as a lamp. The chunky 1970s American tech aesthetic reminds me of filmstrip projectors from grade school and old Bakelite box cameras.

Like all defunct technology, the reviewer carries an aura of nostalgia for the future. But, even more, it exudes the peculiar pathos of media supersession: it's a retrieval device for which storage tokens no longer exist. It sits on my desk, lamp lighted, arms outstretched, little handles dangling, expectant, begging to illuminate strips of film—stories and memories—that are never going to come.

MARK KINGWELL

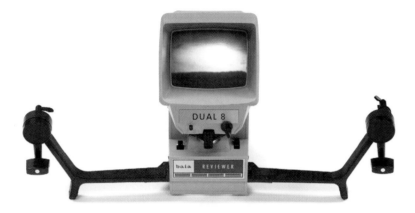

THE SUMMER AFTER COLLEGE
I MOVED
TO AN APARTMENT

in Provincetown, Massachusetts. It was 1992, and my landlady, the first I ever had, rode a bike covered in red plastic poinsettias. An animal lover, she'd crafted a wheelchair for another tenant's partially paralyzed cat, and once when I admired an empty birdcage in her kitchen, she reached into her freezer and pulled out the parrot, its feathers glistening with freezer burn. I loved that bird, she said teary eyed.

I admired my landlady's uniqueness, her style, and her inner P-town-ness that I knew would take me years to obtain, even though I'd strapped shark jaws to my bike's handlebars. That summer she presented me with this vase from the site of Helltown, an early-eighteenth-century pirate settlement near Provincetown, where mad tidal shifts have claimed lives. She'd ridden her bike beyond the breakwater before sunrise, as she did every morning, and pulled the vase from the wet suction of the mudflats. I know nothing about the vase, but I've carried it with me ever since, placing it on every desk I've had.

This tiny delicate object taught me the ability of an artifact to inspire stories and lured me into the world of material culture. I like to imagine a smock-wearing Provincetown artist made it in the 1920s, whose studio was fashioned from the wheelhouse of a boat.

KRISTIN PARKER

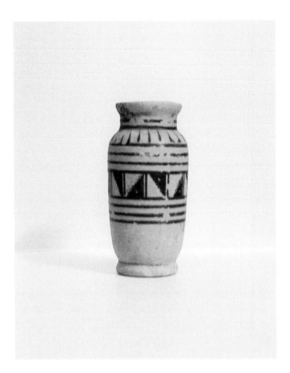

A ROCK WRAPPED
IN A PIE TIN.

It belongs to my husband David. He's had it ever since I've known him. It's typically to be found with the old ATM slips and receipts on his nightstand, but it could be anywhere in the room. I've tried to throw it away many times.

The first time I tried to do so, David told me it was a prop from a film he made when he was in college: a man running through abandoned streets clutching something in his hand. I liked the movie, but I still wanted to throw it away. The next few attempts to get rid of the thing were subtler: I said I wanted to clean out the clutter in the bedroom, in the name of good feng shui. But he wasn't convinced that getting rid of it would improve the flow of energy. My efforts only seemed to renew his attachment to it. I tried ignoring it, but it just got really dusty.

For my last attempt I was more aggressive. "It's just a rock," I pointed out, "wrapped in a pie tin." So David finally explained its significance: The shining object (a bit patina-ed now with age) represents the Precious Thing, he said. The thing you want more than anything else. And once you find it, you must keep it safe.

Why didn't he say that in the first place? I've since incorporated the object into the energies of the room: fire, water, wood, earth (rock), and metal (pie tin). All is in harmony.

KRISTINE CORTESE

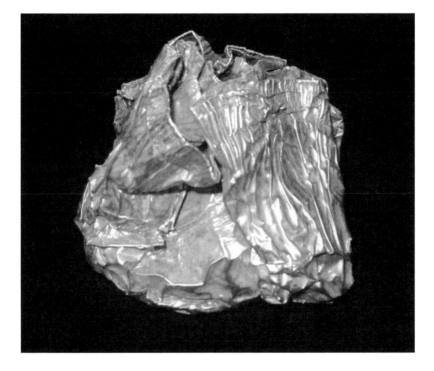

I CAME ACROSS

AN ADULT NOVELTY SHOP

ON EIGHTEENTH STREET

and Broadway in New York that was having a going-out-of-business sale. I bought a few dozen plastic wind-up action toys (humping barnyard animals, a dog receiving a blowjob from a blonde), "Over 30 and Still Sturdy" birthday candles, naughty greeting cards, and thousand-dollar-bill wrapping paper. I also bought the Sexy Camera. I bought the last case of twenty-four.

At first, the Sexy Camera appears to be a child's toy. Then you unscrew the lens cap, and a large pink penis springs out, like the snake-in-a-can trick. I like to imagine the production meetings and research sessions that went into the planning of this item: the mock-ups, the demos.

There is something romantic about unapologetically plastic objects made decades ago. They hark back to a time when people thought plastic was the perfect material for everything. People used to think plastic flowers were a stroke of genius.

The Sexy Camera has become more than a 3-D joke. Its level of absurdity elevates it into the realm of high-low art. It's so innocent and light-hearted, yet so obscene. I don't think the Sexy Camera would be made today.

| KRIS MORAN |

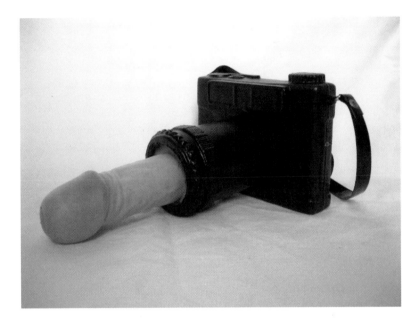

MY GIRLFRIEND AND I

moved several times over the course of seven years: twice in Miami, then to New York, then to Boston, and again within Boston. Each time, when we packed up the bathroom, we'd throw away half the stuff—the old, the rusty, the items we'd gotten tired of looking at, all the useless detritus that builds up so quickly in bathrooms.

No matter how much stuff we'd throw out, we always kept this ugly little ceramic frog that sits in the soap dish. If I'd given it any thought at all, I'd always assumed it was hers and important in some quietly bizarre fashion. Recently though, I was feeling irritable and finally asked my wife why she insisted on keeping it.

I probably didn't really ask: I probably said, "Why do you keep this stupid frog around? He's only got one eye and takes up half the soap dish." She said, "What are you talking about? That's not my frog." It turned out that we'd both assumed that the frog belonged to the other person—and it made sense: Why would there be a half-blind frog in your soap dish otherwise?

In fact, we figured out, the frog had belonged to my ex-wife who had left it behind when she was cleaning out the bathroom and here we'd been carting it about as if it were a prized possession. So now, absurdly, it is a prized possession. It's our one-eyed soap dish frog now, no one else's. Everything else has rubbed off it, and it sits in the soap dish, an accidental symbol of our peripatetic love.

TOM NEALON

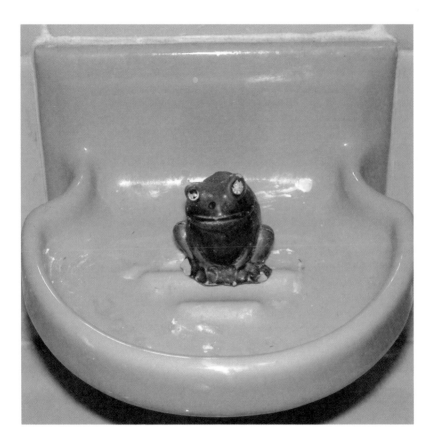

WHEN I WAS A CHILD,
EVERY CHRISTMAS

we'd come into Chicago from our farm way west of the city to visit my grandparents, Mr. and Mrs. P. T. Dolan. My brothers and sisters and I would sit in the front parlor of their home on the South Side—where they'd lived since the first decade of the twentieth century—until it was time for us to enter the house proper and feast our eyes on the Christmas tree. But though the tree's glory was short-lived, a Tiffany-style electric lamp lit up the parlor in glowing colors all year long. I loved visiting my granddad, a lively figure who'd take us down to the Union Stock Yards where he was a Livestock Commissioner, so the lamp was a beacon of joy.

In 1961 my granddad died and my grandmother moved to an apartment and gave away the furniture. Along with the marble-top table on which it sat, the lamp migrated to our farm. It must have been one of the earliest fancy electric lamps. As a teenager I was informed that a man who'd been unable to repay a debt to him had forced it upon my granddad during the Depression.

Years later, when my mother was dying and we were celebrating our last Christmas together, she told me to take the lamp home. "No, Mom, I can't do that. You can't do that," I said. I felt a little bit like Joseph, the best-beloved son of Abraham, being given the coat of many colors. What would my eight younger siblings think if Mom gave me the lamp of many colors? How much would they envy me? What harm would follow? But she insisted.

How little I knew about gifts and love. A few years later, my brother insisted that I also take the marble-top table.

| LINDSAY WATERS |

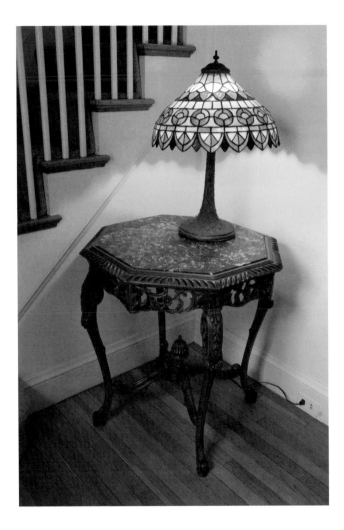

THE *GEORGE'S ISLAND* WAS
THE COMMUTER BOAT
THAT RAN BETWEEN

Boston and Hull for three generations. My grandmother took it to work, and so did my father. I took it regularly all through college and after as I drifted about in the wreckage of my life. A few years ago a new company bought the line and discontinued the run. The passengers were devastated and responded to the news by throwing a farewell party at the pier.

Everyone was there—our loyal, mismatched crew of career commuters and loitering students. We stood below deck, our Happy Hour concoctions in those plastic cups that bead up and sweat no matter how fast you drink. The group I was standing with was trying to figure out how best to capture the life ring. It had become a forlorn flag of fellowship.

Plans were hatched. One guy wanted to throw it overboard and swim out to it. Another thought we should let it ride in on the tide. Donning my invisibility cloak, I sauntered up to the bow, nodding and smiling at the captain. I unhooked the life ring from its cleat on the pilothouse and, swinging it casually like a purse, carried it down the gangway. I put it in the trunk of my car and went back to the party.

KATIE HENNESSEY

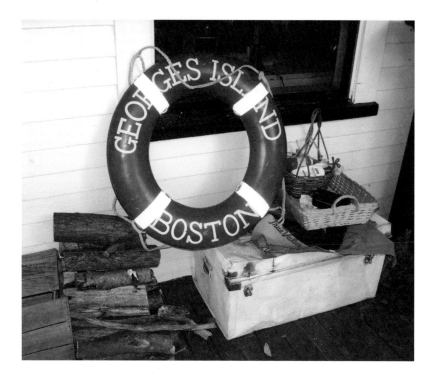

THIS TOWEL

BELONGS TO A WELL-KNOWN ARTIST

from Northern Europe: Let's call her B. Several years ago, B came to New York with her boyfriend, and they stayed with my wife and me for a week. B is one of only two people that my wife and I knew independently before meeting. She'd always had a special place in our hearts.

The four of us had a great time that week, or so I thought. After B and her boyfriend left for the airport, I saw that she'd left her towel hanging on the hook of the guest room. I decided to put it away so that I could give it back to her the next time she stayed with us. About a year later, though, I ran into a friend who also knew B. My friend asked if we'd seen B and told me she'd just spent a month in New York. I didn't know she'd been here, I said. She'd never called us.

Like everyone else, I've lost friends over the years, but almost all of the other breakups were explicable, even justified: people grow apart, like trees. But B stands for those friends whose friendship I've lost without knowing why, and this towel stands for B.

| SINA NAJAFI |

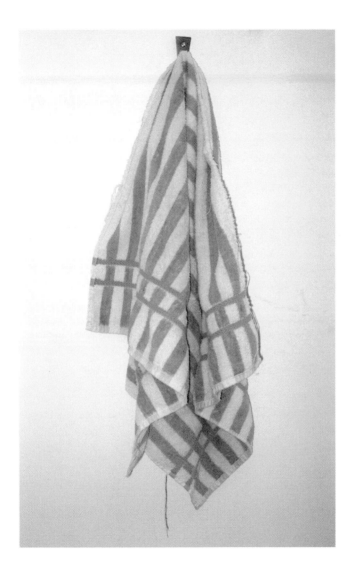

YOU ARE A BANK

THAT HAS NEVER HELD A COIN.

It was almost twenty-five years ago that I found you for sale on a seedy side street in Tijuana. Later that same day some shady border cops shook us down for twenty bucks. You were a silent witness.

You became a fixture in an endless series of apartments from San Francisco to Baltimore to New York. You never complained. Though totally nude, you appear quite comfortable perched on that pile of rocks. Your eastward gaze seems to calmly accept whatever may be lurking around the corner.

Visitors often speculate about the deep and bloody gash on your arm. The location and severity of the wound on such a young child certainly demands some sort of an explanation. But your unfailing smile tells us not to ask.

| REX DOANE |

IN A FORMER LIFE

I LIVED IN HOBOKEN.

The amazing thing was that a family of four had previously lived in the place I thought was so small it was going to squeeze the life right out of me. It was the kind of space that gives you a steady run of dreams specific to living in miserable confinement: there are magnificent palaces spreading out just underneath you; there are grand apartments that may be accessed through the back of your closet, and so forth. This family had moved to the basement apartment, which they considered palatial due to a shed-like addition that thrust out into the back "yard," a storm-fenced pad of concrete.

One day, an assemblage of impossible riches appeared out front by the trash cans: porcelain figures (I think one was Marie Antoinette) and objets d'art. And two life-size ceramic whippets, elegance personified, sitting on ceramic pillows with noses lifted to sniff a rarefied air. They sported real jeweled collars. I furtively looked around and hauled the loot into my apartment. I didn't know where I was going to put it—I would have to get rid of a chair. Later, one of the children downstairs told me her family had had this stuff for a long time, and then suddenly decided to get rid of it. Jeez, a family of four *and* two whippets lived in my tiny apartment?

The bric-a-brac went to a friend who needed targets for his air rifle. But the whippets have been with me now a very long time. A friend once insistently asked if he could borrow one of the dogs; when he returned it several months later, an ear was broken and glued. He would not tell me what had happened.

MELISSA HOLBROOK PIERSON

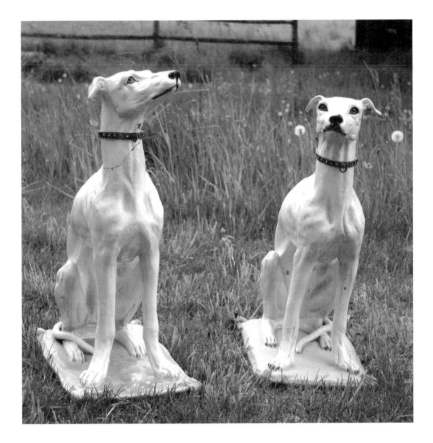

WHEN I LIVED IN
SAN FRANCISCO MY BEST REFUGE
WAS TO GET STONED

on Sunday mornings and walk over the hill, through Golden Gate Park, down to the beach. This one time I got to the big concrete platform where the storm drain opens into the ocean and there was this head sitting on it, looking out to sea; also, hung on the side of the platform, a board with a quasi-allegorical painting of snakes. Someone had committed Art here. I'd only be able to carry one piece away. I deliberated. Really hard.

At work the next day I told other officemates about the Retrieved Art and the Art Left Behind problem; one of these was a woman I was soon to get involved with. A few days later she came to work beaming, bringing me the quasi-allegorical painting of snakes! I immediately drove an unauthorized nail into my office wall to hang it up.

She did that because she loved me. In time, because my first instinct is always to hang up the picture, and because I don't have a second instinct, I got her to change her mind.

This head is hollow but very heavy. It doesn't seem to be exactly ceramic or cement, and it couldn't have been cast in a mold but I also don't see how it could have been stably sculpted. It's anomalous. Those small holes go through, so if you stuff it with Christmas lights it glows dimly.

CLARKE COOPER

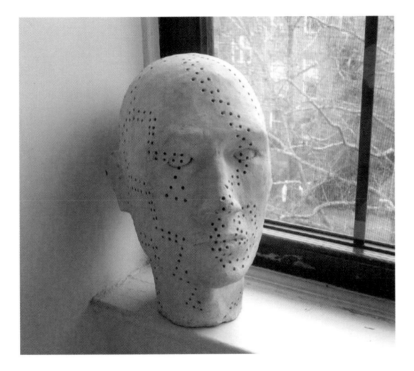

EVERY MORNING FOR FIVE YEARS,
I WAS NOT SO
WELCOMINGLY GREETED BY

my middle-aged, developmentally disabled neighbor across the street. Scotty never smiled and seemed to hate everyone. He never left the perimeter of his mother's lawn and apparently didn't know how to do anything but rake, shovel, take out the trash, and yell in a high-pitched voice. I'd pull out of my driveway and see him there, wearing a neon orange hunting cap, raking absolutely nothing at the same spot that he'd raked the day before. I'd think to myself, "Don't make eye contact!" But I always did. He'd stare at me and neither of us would blink.

Near the end of my fifth year on the street, Scotty stopped coming out of his house. At first, I was thankful. But as time passed, I began to worry. Then one Saturday morning in the middle of January I noticed that his window was wide open. Later that day, a police car showed up. Maybe Scotty and his mother got into one of their screaming matches again? Then a funeral-home van pulled up and they brought out Scotty's body. Although it came as a surprise to me to discover that he knew how miserable his life was, he had killed himself.

The next day Scotty's uncle came over and began furiously carting things off to the dump. He left behind a garbage can in the driveway piled with all of Scotty's earthly possessions. I noticed two little pink feet sticking up into the air.

After dark, I crept across the street to the garbage can, armed with a travel-sized bottle of hand sanitizer. I looked left, then right. I dashed forward, tugged at the feet, and then ran as fast as I could back into my own backyard with my prize. Only then did I look at what I'd rescued. I would like you to meet Mabel.

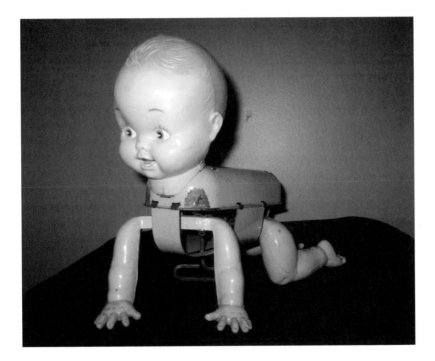

FRESH OUT OF COLLEGE

WITH AN ART HISTORY DEGREE,

SOME YEARS AGO

I was hired by the Oakland Museum to research the history of the Arts & Crafts movement in California. I got paid to do wonderful things like read the daily papers from the period of the San Francisco Fire, scour city directories for potters and metalsmiths, and trawl the census records for descendents of forgotten artisans.

One unknown artist got under my skin. Every reference to Lilian O'Hara, who'd died in 1959, made her seem more interesting and prescient. With her partner, Grace Livermore, she'd been the first to apply wood-burning techniques to native redwood. When I tracked down O'Hara's nephew, he invited me to visit the redwood home she'd built in San Anselmo, which was still filled with her stuff.

The house was a warren of semi-open sleeping porches, a temple of proto-hippie nature worship; O'Hara's spirit was heavy in the air. But although I found weird objets d'art on every wall and boxes packed with books, her Arts & Crafts works were long gone. Inside one box was a stack of O'Hara's bookplates: a fat fairy sitting on an open book, with the William Cowper motto "Books are not seldom talismans & spells." One of these managed to find its way into my notebook. I can't imagine how.

KIM COOPER

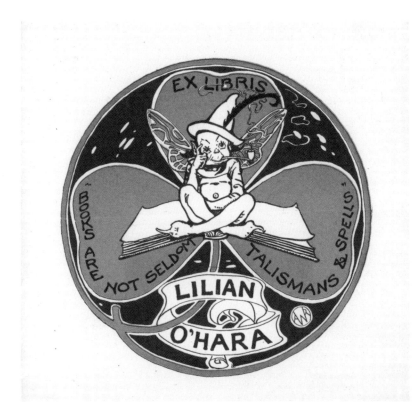

MY DOWNSTAIRS NEIGHBOR,

MARLENE,

WAS SINGLE, SIXTY-ISH,

with white dandelion hair and flowy scarves. She taught an Adult Education course in Cambridge, Massachusetts, on "Ceramics and Meditation." But forty years earlier, Marlene was a young bride in Baltimore, and she and her husband bought this table for their first apartment.

Marlene had chronic health problems that got much worse a couple of years ago, and when she didn't show up for a dialysis appointment, the police kicked in the door and found Marlene on the floor next to it. Her brother in Baltimore, her only relative, told us that all he wanted from Marlene's two-room apartment was their mother's fur coat and china.

I spent two days sorting her stuff into charity piles and trash piles, finding Marlene's vibrant past under layers of her recent ill health and isolation. Behind books on Buddhism, aging, and cat psychology were her graduate schoolbooks: a critical biography of John Cage, books on cognition and development, and Henry Miller paperbacks with sexy abstract covers. Her filing cabinet, buried under crumpled towels and clothing, held grant proposals going back to 1970. Eventually this table emerged, crammed with Agatha Christie paperbacks, and I appropriated it.

Loud neighbors and bad plumbing were the bane of Marlene's existence, but where else could she afford to live in Cambridge? And she was so Cambridge.

| INGRID SCHORR |

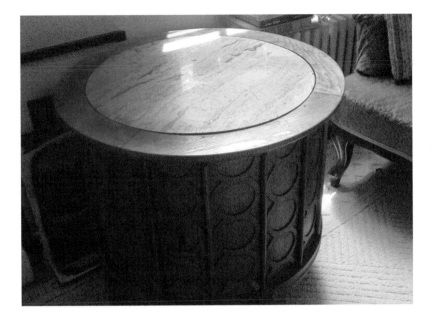

I HAVE TAUGHT

PERFORMANCE ART

to college-age students for years. I have seen everything from troubling personal confessions to a staged fake suicide with a real gun, to a rapid intake of copious amounts of Cheez Whiz, onions, and ice cream immediately followed by regurgitation into a garbage can. But the performance that inspired the most fear and awe in me was the Unicorn Stampede of 2004.

The student who orchestrated the event carefully crafted one hundred horns from white clay. Each participant would hold a horn to his or her forehead and be transformed into a noble unicorn as the herd stampeded down a grassy hill. The image she conjured up was powerful indeed, evoking in me nightmarish visions of students impaled on horns, their eyes poked out as things spun out of control.

Though I was reluctant to stifle the student's creativity, I realized I could not be an effective teacher if I had to spend years in court defending my decision to sign off on the Unicorn Stampede. So I urged the student to pull in the reins when leading the herd down the hill.

The event took place on a beautiful spring day, and, thankfully, like many other performance art events it ran a little late. By the time things were in place the herd had dwindled to about twenty-five unicorns, observers, and photographers. Eventually the group did make its way with horns in place across a busy intersection, over an overpass, and then galloped sedately down a hill. All in all, it was more of a group grope than a battle scene from *Candide.*

MICHAEL SMITH

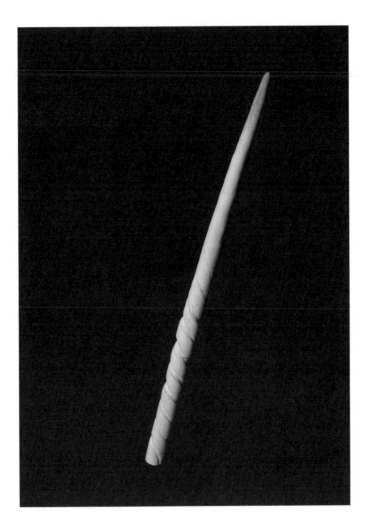

IT'S DEFINITELY AN ANIMAL, THOUGH I'M NOT SURE WHAT KIND.

A dog? A deer? It's like a precocious two-year-old's rendering of the family pet in perverse Technicolor. I first saw him in a junk shop window on New York's Lafayette Street, but I refused to shell out the thirty-dollar asking price. That night, the Japanimal showed up in my dream. So later that week I went back to the shop but it was gone. The owner said some German collector of the genre had bought it just the previous day. I was crestfallen.

About nine months later, on my birthday, I received a box from a close friend. I opened the gift and was shocked to find the Japanimal lovingly wrapped in tissue. It was a terrifying, dreamlike moment. There he was: orange, blunted antlers, bloated squash body, a hyper-extended knee that suggested he was running or crippled or both. How had he returned to me? My friend confessed that she had run out and bought the creature after I had told her about the dream. The shop owner had lied to keep my friend's secret.

I put the Japanimal on a shelf next to my bed, where he keeps a constant, bug-eyed vigil over my dreams.

KEVIN SAUNDERS

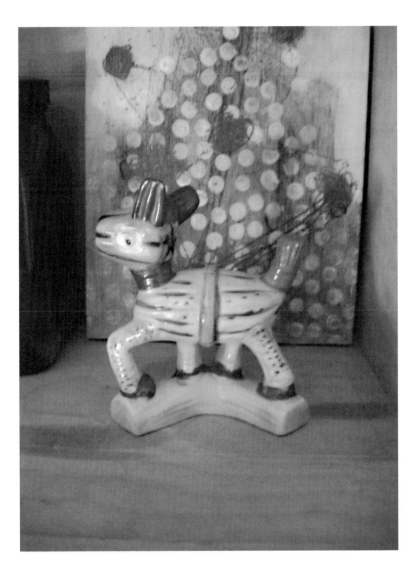

I did, particularly if nobody else wanted to be bothered. Since I didn't have my own desk, I floated around, occupying whatever space was handy and empty. This was in the early 1990s, in Pittsburgh. The mad dash to refinance home mortgages had begun to cool. Whole suites were deserted, reminders of a time in the not-too-distant past when the company enjoyed more bullish days.

I searched every desk I sat at not only to fill the periodic lulls but also out of curiosity, to find pieces of other lives, workers before my time. One slow day, while pawing through an abandoned desk, I discovered this rubber stamp and knew immediately that I had to make it mine. *Certified True Copy.* How strange, I thought, and funny. How could a copy of something ever really be true?

My discovery was luck made manifest. I had recently started writing a story about Copy Copy, a fictional copy shop where a clerk named Tom Again worked the nightshift. Tom dreamed up grand-sounding theories like the Law of Copies, which holds, not originally, that life is but one long and steady decline. An original loses something when copied, Tom posited. A copy of that copy loses a bit more. The law of copies, Tom argued, was the dark twin of the myth of progress. He had ideas, as I had ideas then. And he was stuck, much as I was stuck. I took the stamp, thinking, I'll incorporate this into my work. I'll use it. In a moment of misplaced optimism, I even thought it might help me finish the story, like some magic talisman.

It didn't work. At least not as I hoped. I quit the job, left the story unfinished, and went on to other things.

144

Independent

~~EET · PHILADELPHIA, PENNA · 19107 · USA~~
215-351-0777 · FACSIMILE 215-574-7631
W.PHILADELPHIAINDEPENDENT.NET

CERTIFIED TRUE COPY

vere sending you copies of The
ewspaper. Then came March 2005,
vill remember the paper closed up
d time to mend the holes i
s. We've considered ei
v endeavor, and have
e, we are pleased to b
e Space 1026 gallery
quotas of your periodi

, the proverbial rate of ex
Independent dispensed it.
n in colorful salvos of 1,000.
on — both are interested in cities
erized as attempts to resist
ies of today's mainstream print

e information, visit
n The Philadelphia Independent,

CERTIFIED TRUE COPY

A FEW YEARS AGO

MY BOYFRIEND RYAN THREW ME

A FONDUE-THEMED BIRTHDAY PARTY

that didn't go so well, because he stepped outside to have a smoke just as some plainclothes cops were conducting a Giuliani-induced East Village sweep. I told the officers it was my birthday, and my friends and I pleaded with them to let him go. But their supervisor showed up and that was it.

While Ryan was being handcuffed and dragged away he pleaded with me to go ahead with the party. Despite the unseemly turn of events my friends and I had a great time. But Ryan felt pretty guilty about the whole thing, so he organized another dinner for the following weekend. That night, he walked into the restaurant with a seven-foot-tall package wrapped in brown paper. All conversation stopped at the sight of him making his way to our table. After dinner, I unwrapped it and found myself looking at this enormous bowling trophy. The plaque reads: Felicity Erwin: Interborough Birthday Champion.

On the train back to Brooklyn people stared in awe or cheered us on at the mere sight of the trophy. One guy came up to us at the West 4th Street platform and never actually said anything decipherable, but just kept laughing like he couldn't stop if he wanted to. I couldn't stop cracking up myself. But I also tried to look nonchalant, as if to say, "What? You've never seen a gigantic bowling trophy on the F train before?"

Today the trophy sometimes acts as a coat rack. Someday I'll build it a nook of its own. I picture wood paneling and a blue felt riser.

| LISSI ERWIN |

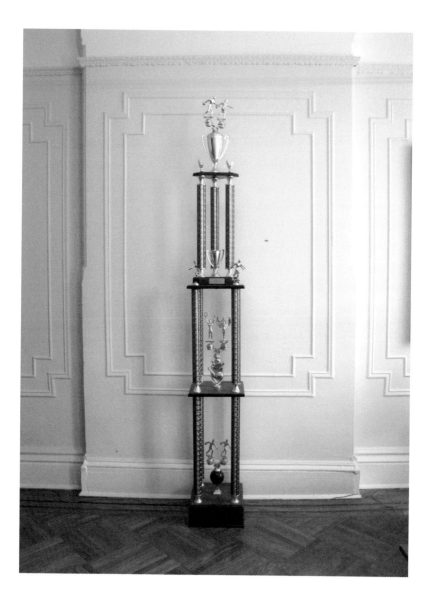

THE ROCKING CRAZY DUCK

CAME INTO MY POSSESSION

AT A REST STOP

in central Pennsylvania. I was a roadie for friends in a Philadelphia band on a weekend tour to Pittsburgh: rock music, rocking duck, ha ha.

But though it was purchased as a joke, over time the Rocking Crazy Duck has come to evoke an intense, even manic energy for me. If the old and flimsy rubber band holding the duck in the package were ever to break, I half-believe that the little guy would be all over the place—he "works on land or in water"—and nothing could stop him. He's become a talisman of energy for me: He "never wears out." Note the crazy bolts of magnetic charge around the border of the package.

He sits above my desk in a place of honor, egging me on: "You running out of steam, Carmichael? If you take the rubber band off, I'll show you some *rocking*! Just give me the chance..."

ROB CARMICHAEL

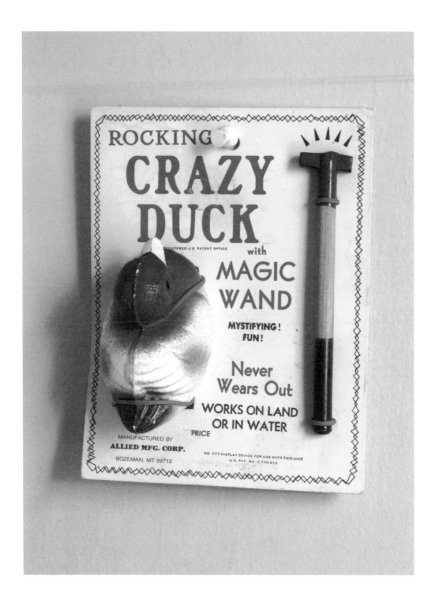

WHEN OUR MOM WAS
TURNING FIFTY
MY SIBLINGS AND I WANTED TO GIVE

her a memorable gift at her surprise party. It was my inspiration to have a studio photo taken of us. The last such photo was from Sears in the early 1980s; in it, I'm wearing a green sweatshirt with ice cream cones made of giant, multicolored pompoms and my sister had one of her self-styled hairdos. It was time for an update.

How to capture the sense that we were cool and confident adults who still had the playful zest of childhood? Inspired, I think, by the Red Hot Chili Peppers, I suggested a rock star–like picture of us in our underwear. We secured my brother's friend Cliff, a professional photographer known for taking pictures of upper-class toddlers running through fields of wheat in perfect outfits.

At first, as Cliff directed us into poses in my apartment kitchen, we felt awkward—our group bath times were long ago, after all. But soon we were laughing, hamming it up: "Woo-hoo! Happy birthday, Mamacita!"

HEATHER KASUNICK

WHEN I WAS A KID,

INSTEAD OF A TEDDY BEAR

OR SECURITY BLANKET

I toted a Mickey Mouse "Soaky." Soakys were cheap, roughly sculpted, blow-molded plastic bottles filled with liquid bubble bath. My Mickey Mouse came to me via the detergent aisle at the King Korn on Forest Avenue, Staten Island. On a family trip to Central Park one weekend in 1962 it vanished forever. I remember crying as we retraced our steps and days later I was still crying. But the Soaky shelf at the King Korn had long been restocked with Flintstones, Deputy Dawgs, and Woody Woodpeckers.

My father wrote to the manufacturer, and—according to family legend—a caseload of Mickey Mouse Soakys arrived at the house along with an offer to cast me in a TV commercial dramatizing my traumatic loss. My idealistic young parents rejected the limelight and let me keep a single Soaky only.

But this was no replacement: he was bigger, he was red, the plastic was hard, his head screwed off, and this Mickey was decked out as a marching bandleader. Not all Mickey Mouses are created equal, I realized at an early age. Is this why I grew up to be a cartoonist? A collector? A connoisseur of crap?

I never sought out another Mickey Mouse Soaky. I anticipated crossing paths with one sooner or later and savored the eventual reunion, which I imagined would be marked by a great shock of recognition and perhaps a transcendent feeling of completeness. However, when I finally did find the Soaky at a flea market in the woods of eastern Pennsylvania, I barely recognized him. This Mickey had two shirt buttons instead of one; his shirt was magenta instead of blood-red; his ears were too low, his nose too small. I took my trophy home, but within a week he was in a box in my closet.

MARK NEWGARDEN

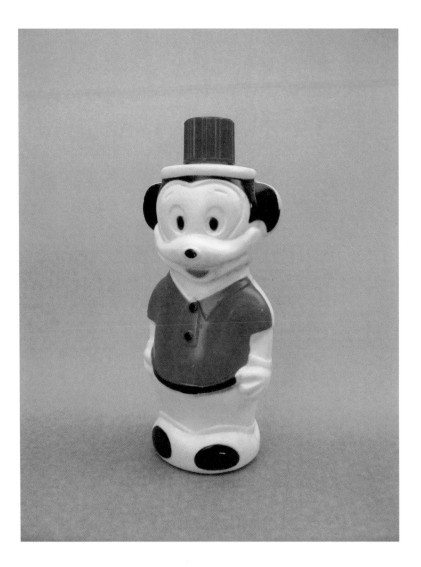

JUNK BROUGHT MY

HUSBAND JOHNNY

AND ME TOGETHER.

The scrapbook was a gift from Johnny, who found it at a thrift store during a road trip with one of his bands—neither of us remembers where. The binder's cover design of 1950s-era teens caught Johnny's eye, but when he looked inside he knew I would love it.

The scrapbook is filled with pages pasted over with colorful images clipped from early-1960s magazines and newspapers, the whole divided into sections like "Clowns and Jesters" and "Cavemen." There's a weird eroticism: The "Animals" section includes a full-page image of a Playboy Bunny's cleavage, not to mention other sexy women dressed as rabbits.

Who was keeping this scrapbook and why? Was it occupational therapy for a mentally or emotionally disturbed adult? Perhaps the pages and pages of adults dressed as children—and a corollary page of little girls playing dress-up—are a clue. I like to think these are a comment on the creator's self-image, an intellect balanced between adult and child. But it's better not to know the true story. I'd rather make it up.

LYNN PERIL

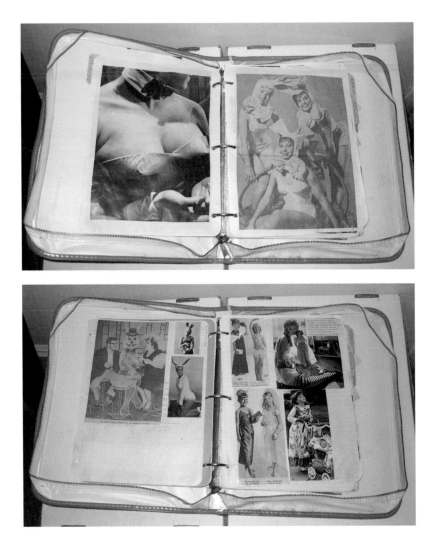

ON A SUNNY MORNING

IN THE EARLY 1970S

MY NEIGHBOR,

the small shrill widow of a minister and professor of theology at Harvard, dragged me into her house and opened the drawer of her late husband's desk. Choose, choose anything, she said. From a miscellaneous collection of stuff I took this wedge of brown bread with a label: "Bread given the prisoners at Saar-Alben; and by one of them to me at Luneville Nov. 19, 1918."

I had never held such a venerable piece of food. The label is always slipping off the diminished lump—but it is the label that evokes ideas of war, capture, suffering, and anticipated salvation either from prison or, because the bread was given to a minister, in the sight of God. Or perhaps the prisoner was simply offering up evidence of the miserable food he had endured. I have no idea why the widow selected me (almost a stranger) to have this bread, but I have kept it as a talisman of the transitory itself—a contradictory talisman, really, for bread is a daily deal, it comes and goes. And it must be fresh. But this bread is antique.

I don't know that I have always made the right decisions in my efforts to preserve it. About ten years ago, observing its surfaces shrinking as if it were being undermined, I sealed the bread in a plastic bag with a few preservative crystals. Tiny black beetle corpses fell out of the air holes. Then a new kind of hole, like bomb craters, appeared on all sides of the bread, including the darker, smoother crust. The poison that had killed the beetles now threatened to tunnel the bread into nothing. So I sprayed it with a toxic varnish. It survives today as a symbol, though as food it is fit for neither man nor vermin.

ROSAMOND W. PURCELL

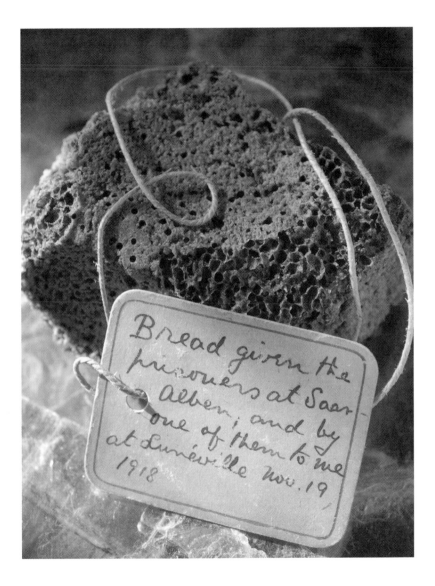

MY DAD ALWAYS

WANTED TO BE IN BASEBALL.

Not being a very good player, though, he decided to go to umpire school after World War II. But he was discouraged from becoming an umpire because those jobs went to former baseball players. He then decided to become a sports announcer. But Mel Allen, a famous sportscaster at the time, talked him out of it. So instead of becoming an umpire or a sportscaster my dad went into advertising.

I don't remember when my father gave me his glove, or why my parents never bought me a new one. I have never been good at sports. I didn't make little league—only farm league. They put me in left field. I was the oldest kid and I was scared of the ball. I'd wait for it to come to me, getting closer and closer, bigger and bigger in my field of vision. I'd get under it, praying, "Please don't let it hit me." The ball would always bounce out of that thick glove and onto the ground.

MICHAEL LEWY

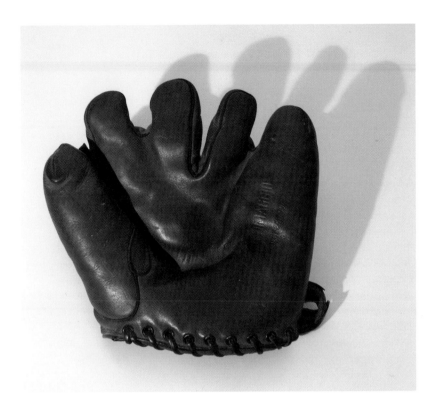

MY MOTHER HAS A
CABIN ON A LAKE
IN MAINE.

When I was thirteen, I was fishing off the dock and accidentally caught a large snapping turtle. It had chewed on the hook so that the barb was sticking out of its eye. I put it out of its misery by cutting off its head with my jackknife.

I threw the body into the water, walked up to the cabin, and told my little brother about it. He was eight and he loved turtles, so he started crying. I told him I'd made up the whole story, and he felt better. Then he went swimming and the floating headless turtle bumped against his neck. He screamed and ran to the cabin. My older brother cut off the long, prehistoric-looking tail. I kept it and dried it out in a plastic bag in our big deep freezer.

Twenty years later I was retelling the story to my laughing family and just as I asked my brother if he remembered the feeling of that headless turtle up against his neck, we heard the hysterical voice of his six-year-old son screaming, "It's not funny for the turtle!" Five years after that I was telling the story to my sister's seven-year-old and he got a stony horrified look on his face and started to cry. My sister told me that my nephew was in his "turtle stage."

Neither of the boys has seen the tail, but as soon as their kids are old enough, I'll pull it out some night around a campfire.

TONY MILLIONAIRE

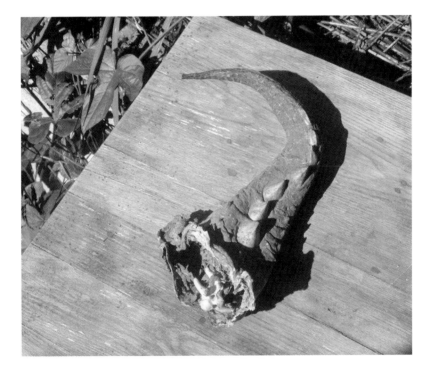

MY HIGH-SCHOOL

GIRLFRIEND, BECKY M^CGEE,

GAVE ME THIS US NAVY

one-hundred-pound practice bomb for my seventeenth birthday, our senior year. I'll never forget her coming up the front walk with this bomb wrapped in newspaper—that's exactly what it looked like, a bomb wrapped in newspaper. She gave it to me because I've been interested in World War II since I was five, when I gave my grandfather a drawing of a ship being bombed by Nazis.

McGee and I ended up having a big argument shortly after she arrived. I'd gone home early from school with my friend Rose. My aunt and uncle and grandparents were coming over to celebrate my birthday and my mom had to run out to the grocery store. I could have sworn Mom told me that bottle of white wine was my birthday present, so while she was out Rose and I drank the whole thing. That's when McGee showed up. Nothing was going on between me and Rose, but it didn't look good.

McGee and I later made up and we went off to art school together, where she dumped me for another guy in the dorm.

TONY LEONE

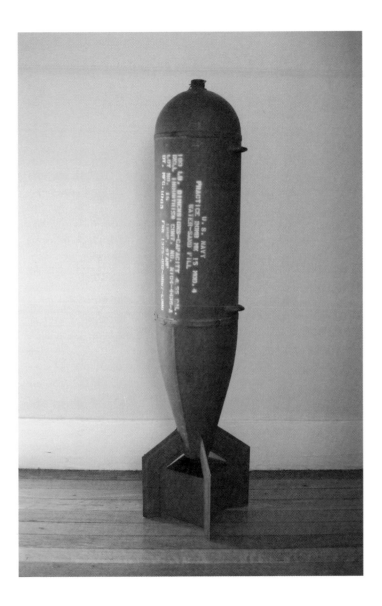

ONE NIGHT IN 1991,

JUST BEFORE CHRISTMAS,

I was walking down St. Mark's Place in Manhattan, heading for my tiny but charming bed-sit on Sixth Street. I'd been around the neighborhood for more than twenty years by then. I remember, for instance, when people started selling stuff on the street, circa 1980. (Earlier, when you found things, you'd either take them home or leave them for others to take; the first harbinger of Reaganomics was when people started selling what they scavenged.) Astor Place became a 'round-the-clock market, delirious and phantasmagoric. It was at once a thieves' market, a collective yard sale, and the spillway of the collective unconscious.

That night a guy selling old movie posters caught my eye. His prices were high and the sheets were damaged—I surmised he'd fished them from a dumpster. Something made me ask him if he had any incomplete posters. He presented me with a plastic bag full of scraps for ten dollars, one sawbuck. They were rough, vivid, varied, and, because they had come apart along their creases, more or less equal in size. A light bulb appeared directly over my head.

There are pieces of four posters here. Two of them are different advertisements for a single minor horse opera, *West of Pinto Pass*, circa 1950, starring Crash Corrigan; another is unknown; the fourth is a three-sheet for an early (1962) picture by Elio Petri, writer-director of such 1970s radical head-scratchers as *Investigation of a Citizen Above Suspicion*.

During the 1950s, artists in Italy and France cut down layers of movie posters from walls and exhibited them, unaltered, as art. They called their work décollage. In that spirit I propose my untitled piece as the founding work of a new, revolutionary school: démontage.

LUC SANTE

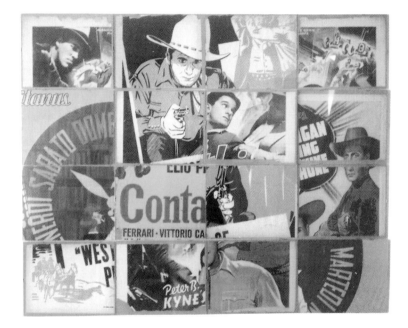

A PLASTIC DOG WITH
A LARGE HEAD.

My nicest ex-boyfriend purchased it at a thrift store when we were still together, about a decade ago. He recalls fondly, "It reignited a sexual fire between us that burned so bright that beings on the sun took notice and saluted." How very apt the sentiment.

While the hangdog, as I call it, may not impress instantly as a fetish object, I think I speak for all those whose secret desires hinge upon the risible when I say the dog's utter mournfulness was for us like the purest, highest note of a great aria. Is it not in the artistic expression of grief that we find our most sublime communion? The dog had a miserable nobility—it pained us to look at it, and to think of all such dogs, wherever they might be. When we stood the dog on the nightstand, overlooking the bed, and saw with what solemn despair it regarded our barely competent fumblings, we tasted in our mouths the bitter ashes of our own deaths. The recognition brought to our sweaty exertion a sort of disgruntled urgency.

But then, not long after we bought the dog, our relationship petered out. In the division of goods the dog defaulted to me, and now has pride of place in my mostly empty house.

LYDIA MILLET

MY LOVELY WIFE AND

I WERE YARD SALING

one scorching August afternoon. We had exhausted ourselves looking at stuff even the junkyard would prefer not to have. We had just about called it a day when from the car we saw these sunglasses in a yard sale's "free" box. Too embarrassed to take them without looking at the other junk we decided to drive around the block and then jump out to fetch the glasses and speed off. The plan went off without a hitch.

The following spring, while packing for a friend's wedding, I figured the glasses would make an amusing distraction for the long road trip. Once arriving at the wedding I realized that if I loved them so much then why wouldn't everybody? The glasses brought out hidden aspects of everyone's character, as though people wearing them found it unbearable to simply carry on as they previously were.

These are not just sunglasses, but an instant good time.

CRAIG LUPIEN

about the contributors

JENNIFER ALDEN
is a graphic designer living in Cambridge, Massachusetts.

CHIKA AZUMA
is a New York, New York–based graphic designer.

MATTHEW BATTLES
is the author of *Library: an Unquiet History* and is working on a book about the sentimental history of handwriting.

KELLY BLAIR
is an artist living and working in Brooklyn, New York.

WICKHAM BOYLE
is a TriBeCa, New York–based writer. Her latest book is *Mid-life Mambo*.

ROB CARMICHAEL
is a graphic designer based in Brooklyn, New York. His most recent project is *Gore*, a book by musicians Black Dice and photographer Jason Frank Rothenberg.

LISA CRYSTAL CARVER
lives in Dover, New Hampshire. Her most recent book is *Drugs Are Nice*.

MEGAN CASH
is a children's book author and illustrator who lives in Brooklyn, New York.

NAOMI CHICHIWAN
is a graphic artist living in Belmont, California.

JEN COLLINS
is a Los Angeles, California–based writer and performer.

CLARKE COOPER
is a former computer programmer.

KIM COOPER
edits *Scram*, a journal of unpopular culture, and leads true-crime bus tours in Los Angeles, California. Her latest book is *Neutral Milk Hotel's In The Aeroplane Over The Sea*.

KRISTINE CORTESE
is an artist and co-owner of City Feed and Supply in Jamaica Plain, Massachusetts.

BETH DANIELS
lives in northern Virginia.

KOSTA DEMOS
is a poet, picture framer, and political activist. He lives in Jamaica Plain, Massachusetts.

REX DOANE
is a DJ on the independent New York radio station WFMU. His longtime show, *Fool's Paradise*, airs Saturdays from noon to 3 p.m.

WILLIAM DRENTTEL
is a designer and publisher who works from the Winterhouse Studio in northwest Connecticut. He is president emeritus of the AIGA, a trustee of the Cooper-Hewitt National Design Museum, and a fellow of the New York Institute of the Humanities at NYU.

LISSI ERWIN
is a graphic designer and principal of Splendid Corp., a Brooklyn, New York–based design studio.

THOMAS FRANK
is author of *What's the Matter With Kansas?* and editor of *The Baffler.*

CHRIS FUJIWARA
is a freelance writer and film critic. He is the author of *Jacques Tourneur: The Cinema of Nightfall* and a forthcoming book on Otto Preminger.

JOSHUA GLENN
is a Boston, Massachusetts–based writer and editor, currently at the Boston Globe. He used to publish the zine and journal *Hermenaut.*

BILL GRIFFITH
is a nationally syndicated cartoonist. His latest collection of *Zippy The Pinhead* comic strips is *Connect The Polka Dots.*

A. S. HAMRAH
is a writer living in Brooklyn, New York.

CAROL HAYES
is a New York, New York–based designer and artist.

JENNIFER MICHAEL HECHT
writes poetry, philosophy, and history in Brooklyn, New York. Her recent books are *Funny* and *Doubt: A History.*

KATIE HENNESSEY
is a writer and editor based in western Massachusetts.

JULIAN HOEBER
is an artist and filmmaker living in Los Angeles, California. His last film was called *Talkers Are No Good Doers.*

JOEL HOLLAND
is a Brooklyn, New York–based illustrator.

HEATHER KASUNICK
is a visual artist and public high school art teacher. She lives in Northampton, Massachusetts.

JOHN KEEN
is a cartoonist and animator currently residing in Brooklyn, New York.

JOHN F. KELLY
is a writer living in Pelham, New York. His work has appeared in numerous publications and anthologies.

JOE KEOHANE
is the editor of *Boston's Weekly Dig*—an alternative newsweekly—as well as a columnist at *Boston* magazine.

MARK KINGWELL
is a professor of philosophy at the University of Toronto and contributing editor of *Harper's* magazine. His most recent book is *Nearest Thing to Heaven: The Empire State Building and American Dreams.*

GREG KLEE
is the deputy design director for the *Boston Globe*. He lives in Nahant, Massachusetts.

JAMES KOCHALKA
is a cartoonist and rock star. His most important ongoing work is *American Elf*, a daily diary in comic strip form. His most recent musical release is titled *Spread Your Evil Wings and Fly.*

MARIA KOZIC
is a multifaceted artist currently based in New York, New York.

AMY KUBES
lives in El Cerrito, California. A monograph of her photographs, titled *Surrogate*, was published in 2001.

TONY LEONE
is a graphic designer living and working in Jamaica Plain, Massachusetts.

MICHAEL LEWY
is an artist living in Jamaica Plain, Massachusetts. His most recent book is *Chart Sensations.*

MIMI LIPSON
lives and works in Philadelphia, Pennsylvania.

PAUL LUKAS
is a Brooklyn, New York–based writer.

CRAIG LUPIEN
is a New Hampshire–based artist.

PAUL MALISZEWSKI
lives in Washington, D.C. His writing has appeared in *Harper's*, *Granta*, and *The Paris Review.*

JESSE MILDEN
is a designer based in Seattle, Washington. He designs for print, web, and skateboard grip tape.

AUGUST MILLER
is a book and mixed media artist. He lives in Golden, Colorado.

LYDIA MILLET
has written five novels, including *Oh Pure and Radiant Heart* (2005) and *My Happy Life*, which won the 2003 PEN-USA Award for Fiction.

TONY MILLIONAIRE
is the creator of the comic strip
Maakies and the *Sock Monkey*
series of children's books, and
he is most recently the author
of *Billy Hazelnuts*. He lives in
Pasadena, California.

KRIS MORAN
is an artist and lives in New York,
New York. She works in the
film industry.

SINA NAJAFI
is editor-in-chief of *Cabinet*
magazine.

TOM NEALON
owns and operates Pazzo Books,
a used and rare bookstore in
Boston, Massachusetts.

BECKY NEIMAN
is a Los Angeles–based writer,
producer, and director. Her
work has appeared in magazines,
festivals, and on television.

MARK NEWGARDEN
is a cartoonist living in Brooklyn,
New York. His most recent book is
We All Die Alone, a retrospective
collection of his work.

JOSH OZERSKY
writes frequently about food.
As "Mr. Cutlets," he is the author
of *Meat Me in Manhattan:
A Carnivore's Guide to New York*.
He is currently at work on a
cultural history of the hamburger
in America.

KRISTIN PARKER
is an archivist living in Brookline,
Massachusetts.

LYNN PERIL
is the author, most recently, of
*College Girls: Bluestockings, Sex
Kittens, and Coeds, Then and Now*.

MELISSA HOLBROOK PIERSON
is the author of *The Perfect Vehicle,
Dark Horses and Black Beauties*,
and *The Place You Love Is Gone*.

MIMI POND
is a writer and cartoonist who lives
in Los Angeles, California.

ROSAMOND W. PURCELL
is a photographer and writer who
collaborated with Stephen Jay
Gould on three books, including
Finders Keepers: Eight Collectors,
and with Ricky Jay on *DICE:
Deception, Fate and Rotten Luck*.
Her most recent book is *Bookworm*.

RICK RAWLINS
is a Boston, Massachusetts–based
graphic designer, illustrator, and
adjunct faculty member at the Art
Institute of Boston.

RICHARD SAJA
is an artist who also owns and
operates Historically Inaccurate
Decorative Arts (HI!), a small firm
based in New York, New York.

LUC SANTE
is the author of several books including *Low Life* and *The Factory of Facts*.

KEVIN SAUNDERS
is an art therapist with a private practice in New York, New York.

DAVID SCHER
is a New York, New York–based artist.

INGRID SCHORR
lives in Cambridge, Massachusetts, where she works in the arts and in education.

HENRY SCOLLARD
is a Boston, Massachusetts–based architect.

DMITRI SIEGEL
is a designer and writer. He is co-publisher of *Ante*, an annual journal of art, design, and cultural inquiry.

HELENE SILVERMAN
is a Brooklyn, New York–based designer. Recent book projects include *We All Die Alone* and *In Flagrante Collecto*.

MICHAEL SMITH
is an artist who lives in Brooklyn, New York, and Austin, Texas. He teaches performance art at The University of Texas at Austin.

PATRICK SMITH
is a columnist for Salon.com and the author of *Ask the Pilot: Everything You Need to Know About Air Travel*. He lives near Boston, Massachusetts.

MARILYN BERLIN SNELL
is a San Francisco, California–based journalist and editor.

JENNIFER TILL
lives in Oakland, California.

CHIP WASS
is an illustrator based in New York, New York.

LINDSAY WATERS
is executive editor for the humanities at Harvard University Press. His most recent book is *Enemies of Promise: Publishing, Perishing, and The Eclipse of Scholarship*.

DEB WOOD
is an award-winning book designer. She is the design director for Princeton Architectural Press and lives in Brooklyn, New York.

LAURA ZAZULAK
is a retired pastry chef originally from the Boston area who currently resides in New Hampshire.

photo credits

All photographs by the contributors,
or Carol Hayes, except as follows:

REX DOANE
Coco Doane

LISSI ERWIN
Ryan Murphy

KATIE HENNESSEY
Brook Batteau

JOHN F. KELLY
Kristy Coviello

MARK KINGWELL
Michael Cullen

MIMI LIPSON
Tucker Stilley

JESSE MILDEN
Mark Sullo

MELISSA HOLBROOK PIERSON
Jenna Knudsen Brantmeyer

LUC SANTE
Jenna Knudsen Brantmeyer

HELENE SILVERMAN
Norman Hathaway

MICHAEL SMITH
Roberto Bellini

LINDSAY WATERS
Paula Lerner

DEB WOOD
Dave Konopka